Art &
Design

for
learning

Art
across the
curriculum

DAWN & FRED SEDGWICK

Series Editor Margaret Morgan

Hodder & Stoughton

A MEMBER OF THE HODDER HEADLINE GROUP

British Library Cataloguing in Publication Data

A catalogue record for this title is available from The British Library

ISBN 0 340 62730 1

First published 1995
Impression number 10 9 8 7 6 5 4 3 2 1
Year 1999 1998 1997 1996

Typeset by Wearset, Boldon, Tyne and Wear.
Printed in Great Britain for Hodder & Stoughton Educational, a division of
Hodder Headline Plc, 338 Euston Road, London NW1 3BH by
Scotprint Ltd, Musselburgh

Contents

Series preface: Art and design for learning

Art and design for learning is a series of books which aims to provide a number of individuals involved in teaching with a platform for which to write about working with children and the thinking which lies behind their work.

The series authors are all experienced teachers and educationalists. They have had the privilege of visiting and working in schools, or of working with groups of teachers who have generously given permission for their children's work, and some of their own thoughts, to be included.

In the climate of intense curriculum development and consolidation created by the introduction of the National Curriculum for England and Wales, there was a great fear amongst some teachers that room for individuality and inventiveness was in danger of being lost. If this had been the case, it would of course have been disastrous, but there was no need for it to happen.

Research historians and cooks experimenting with fifteenth- and seventeenth-century bread and cake recipes encountered failure until they realised that the key ingredient was never listed. This was because all the practitioners knew it to be such a basic necessity that everyone concerned would already know about it. The unlisted ingredient was yeast.

The same principle could be applied to many of our curriculum documents. The yeast in art and design education must surely be the life, energy and individuality of the child and the teacher, working creatively with the ingredient of experience and the means. Any defined curriculum agreed upon by others and presented to an establishment, an authority, county or state is inclined to appear restrictive at first glance, especially if we personally have not been responsible for drafting it. What we are able to do with it will depend on whether we see it as a platform to work from, or a cage to be imprisoned in.

It is therefore always very important to coolly appraise the nature and content of the work we are undertaking with the children in our schools and to think carefully about our personal philosophy and

values. We need to identify areas of any imposed curriculum that we are in fact already covering and then consider those which call for development or may need to be introduced. It is only when we really understand the common denominator which lies behind these areas of experience that we can assimilate them into a holistic and coherent developmental pattern on which to base our strategies for practice.

In simple terms any sound curriculum pertaining to art, craft and design must surely require a broad, balanced, developmental programme which has coherence and respects the experience, strengths and weaknesses of individual children, thereby enabling them to think, respond and act for themselves. Perhaps the real evaluation of a good teacher is to see whether children can proceed with their learning independently when he/she is no longer responsible for them.

The curriculum should make it possible to introduce children to the wonders and realities of the world in which we all live and should include art, craft and design forms from our own and other cultures and times. These can prove to be an enriching experience and can broaden the children's expectation of the nature of human response together with some experience of different ways of making art and · design forms.

The curriculum should enable children to see the potential, and master the practice, of any relevant technologies, from the handling of simple hand tools to the world of information technology. It should enable them to work confidently in group and class situations as well as individually: thinking, making, appraising and modifying the work they are undertaking, negotiating skilfully with one another and discussing or talking about what they are doing, or have done. All of these aspects of education can be seen in the context of National Curricula which have, in the main, been based on some of the best practices and experience of work in recent years.

Intimations of the yeast component are clearly apparent in these selected extracts from *Attainment Targets and Programmes of Study for Key Stages 1 and 2*. (It is also very interesting to note the clear differences in requirements between the two stages; at seven and at eleven years of age. Stage 2 assimilates and develops Stage 1

requirements, building on them developmentally with specific additions.) At Key Stage 1 (seven years) the operative words are:

investigating, making, observing, remembering, imagining, recording, exploring, experimenting, responding, collecting, selecting, sorting, using, recreating, recognising, reviewing, identifying, describing in simple terms and explaining what they think and feel.

There is a very strong emphasis throughout on *direct experience, looking at* and *talking about*. At Key Stage 2 (eleven years) the following expectations are added:

selecting and recording; experimenting with ideas; experimenting and using; experimenting–developing–controlling; developing skills for recording; recording observations and ideas; collecting visual evidence; reflecting on and adapting; identifying how...; recognising in which ways...; comparing; expressing ideas and opinions.

What could be clearer in suggesting a lively educational experience? I believe that individuality and inventiveness are firmly based on having the right attitudes and they usually thrive best in the context of vehicles such as interest, happenings and the building up of enthusiasm and powerful motivation. The overall structure, balance and developmental nature of any sound curriculum model can allow content to flourish in lively interaction between children, teachers and the world of learning experiences.

If we persist in hardening the content of the National Curriculum in such a way that we are not able to manoeuvre or respond to the living moment, then we have ourselves forged the links of the chain which binds us.

The books in this series do not aim to be comprehensive statements about particular areas of art, craft and design experience but they are vigorous attempts to communicate something of the personal, convinced practice of a number of enthusiastic professionals. We hope that they will also offer enough information

and guidance for others to use some of the approaches as springboards for their own exploration and experience in the classroom.

Margaret Morgan
Series Editor

Preface

. . . fine art is the only teacher except torture

George Bernard Shaw

Approaching subjects in a cross-curricular context can produce work of great value or quite the opposite. It is important to visualise the value of the kind of work which might be undertaken before accepting the idea as necessarily good. There is the danger that content can be left to meander aimlessly and time consumingly. The best of all worlds is a holistic approach handled by an enthusiastic teacher who has a deep understanding of the ways in which children develop and learn, together with an understanding of the true nature of the individual disciplines involved.

It is crucial for teachers to realise that each child functions as a whole being responding to the world and its challenges by using all available faculties and senses. This is Fred and Dawn Sedgwick's initial premise in this book. Adults, with their long-lived traditions and methods of schooling, have fragmented learning into many different facets, sometimes for better, sometimes for worse. It is a particular method which allows us to consider specific aspects and ways of learning, but it does not define or depict whole areas of experience.

When we begin to work with children from any particular discipline base, other subjects can sometimes be seen as somewhat feeble appendages which hardly require any teaching at all. This is the very opposite of a liberating experience for pupils. So 'integrated' work at this level brings together separate areas of subject matter which in the child's experience in early primary education has quite naturally never been divided.

In looking at the experience of the primary school child we should above all see that he or she brings a driving personal interest and openness to experience. Work can then range through searching and researching by means of logical and intuitive modes of thinking and can also incorporate sensory learning, feeling response and personal discernment. A variety of practices are quite naturally involved in thinking, making and doing of all kinds; they can include talking,

making sounds, writing, moving, drawing, painting, modelling, constructing or any other ways of responding. The ways in which children are enabled to learn in the primary school are crucial. This surely must be the best time to teach children to attune, to look, to listen, to feel, to respond personally, to select, to sequence and to present. To have the ability to understand how natural interrelationships make up whole experiences will undoubtedly stand them in good stead as their education proceeds.

Beside the holistic experience another ingredient must be taken into account in a cross-curricular approach. This is the nature of particular disciplines, in this case art experience and education. Art education has not necessarily been taking place because the child has been asked, or been given the opportunity to draw, paint or model, any more than a child who has very little experience of handwriting understands language and its potential, having been encouraged to put down a few words. It is true that personal enthusiasm and involvement can produce great leaps of ability, and that maturation will make some difference to work, especially for the gifted, but these are often the exceptions. We cannot be satisfied as teachers that this kind of approach alone can educate our children.

Art can be seen as a unique way of responding to experience which is not in fact encapsulated in any other area of learning. It pertains to logical and intuitive responses to experiencing and using colour, line, tone, pattern, texture, form and space, the very elements which add up to become the 'language' of art. Art is not only nonverbal, it is also preverbal; these are facts which underline the importance of this mode of experience, communication and expression for the balanced adult as much as for the young child.

The National Curriculum is quite explicit in its requirement for children to be able to handle the elements of art in practice, and the need to show a growing understanding of them and their potential as they continue through their school careers. The need for a developmental programme of art in its own right to take place is paramount. This is to be supported by the children using sketch- and notebooks, and being given opportunities to experience, enjoy and wonder at art and design forms all over the world, from the past and the present.

If cross-curricular art and design can be seen in the context of this

growing experience of art in its own right then the educational possibilities are rich indeed. Dawn and Fred Sedgwick show a clear understanding of this approach and present us with a splendid collection of case studies and thoughts on education from their own, and from friends and colleagues' teaching. They clearly regard Leonardo da Vinci's thoughts as relevant to today's art students. It is interesting to think that when Leonardo was working he was often neither undertaking writing followed by illustrating, or making drawings supported by making explanatory notes. Instead he was researching and working out his thoughts using words for things which could be explained in words, and using drawings for the aspects which only drawings could define. Both activities were equally important to him, and I would wish to suggest, drew equally on his intellectual powers.

Good cross-curricular experience can lead to creative working of a high order, where teachers can see children growing in understanding and ability. Teachers are rewarded when they discern evidence of pupils thinking, researching, exploring, experimenting, developing ideas, sequencing and using appropriate skills based on confident personal involvement in cross-curricular learning.

Acknowledgments

We would like to thank the following teachers, headteachers and advisers and others who have allowed us to reproduce work which children have done with them:

Stuart Knibbs, Marie McKenna, Celia Davies, Janet Crook, Chris Romney, Julie Fearnhead, Brenda Chapman, Valerie Edwards, Mike Davies, Paul Waite, Ruth Plumb, Annie Glen, Peter Moore, Simon Knott, Henry Burns Elliot, Wendy Smith, Hayley Marsburg, Roger Amos, Judith Smith, Sophie Boyd, Duncan Bathgate, Duncan Allan, Diane Rolphe, Norma Lutchford, Anne Fletcher, Linda Appleby, Angela Jackman, Eunice Frances.

We have reproduced work from the following schools:

Murrayfield Primary, Ipswich; Goldington Middle, Bedford; Milton Infants School, Cambridge; Ely County Infants, Cambridge; Bedford Preparatory; South Hill Primary, Hemel Hempstead; Hartest First, Suffolk; Rose Hill Primary, Ipswich; Ryvers Combined, Slough; King's Langley Primary, Hertfordshire; Clare Middle, Suffolk; Sprites Junior, Ipswich; King's Sutton Primary, Northamptonshire; Bentley Primary, Ipswich; Talycopa Primary, West Glamorgan; RAF Feltwell Elementary, Norfolk; Tattingstone Primary, Ipswich, Dringhouses Primary, York.

We apologise to anyone we have inadvertently missed.

Photography by Henry Burns Elliot and Simon Knott (James Daniel Daniel John Press, Ipswich)

We are especially grateful to Margaret Morgan, our editor, for all her wisdom and kindness; to Daniel Sedgwick, for valuable help, encouragement and tolerance; and to David Turner, for his permission to reproduce Freda Downie's painting 'Girl in a Straw Hat'.

This book is dedicated to all the children whose work is represented here.

Thank you.

1 Art across the whole curriculum

What lives in art?

I see small insects
crawling crawling.
I see tropical birds
calling calling
in a painting painting.

I see sly tigers
prowling prowling.
I see a cheetah
howling howling
in art, in art.

I see all the animals of the world
crawling
calling
prowling
howling . . .

How does art see me?

child's poem

The power of art stems from its function as a teacher and from its relation to other parts of life and life's disciplines.

Art can also be seen merely as a comforter, a way of looking at the world that muffles its barbed edges. If art doesn't cheer us up, it is of no use. Art, at this low level, is a matter of passing time, of giving pleasure, a hobby.

But far more importantly, art (and craft), offers, in both the making and the viewing, scope for learning. For example, look at the products of fine artists, textile workers and weavers, tapestry makers, stained glass makers, and those ceramicists whose pieces seem to live

in a space between pottery and sculpture. We have, in our home, a carved 'story chair' from Malawi (see figure C1 on page 113 in the colour section) which, as well as being comfortable to sit on, tells us a tale as we look at it. Such work is art, because in the vital sense it is about learning. It exists on the edge between what we know now and what we might know soon.

Such craft (and art) is concerned with two kinds of learning: learning what generations of craftspeople have done, and helping us (and the maker) to extend our knowledge of ourselves into the future.

Irrespective of how much joy or pleasure art gives us as we walk around a gallery, or leaf through a book of reproductions, art also helps us *learn*. This book is about two key words: art and learning. Art helps us learn about

- ourselves
- the world around us (including other people)
- the nature of art itself
- the materials which are used in the making of art
- our ideas and thinking

We don't, of course, mean that joy and learning are separate. We smile in pleasurable memory as we look at the girl on her first date in Auguste Renoir's painting *La premiere sortie*, or as we enjoy the technique used in the portrayals of the old men in Leonardo da Vinci's sketchbooks.

But looking at Leonardo da Vinci's old men, we anticipate, usually unconsciously, the distresses and pleasures of old age. We reflect on them, and thereby learn about them. And thus we learn, literally, about life.

Learning is probably the basic difference between the purely traditional crafts and art. Such crafts can be functional, or they can be made merely to use up time (they are pastimes). On the other hand, works of art are teachers.

If we translate this into curriculum terms, we find that art helps us learn about many aspects of life:

- human biology, personal and social development, psychology and physical education (ourselves); physics, chemistry, mathematics, technology, history, geography (the world around us); language, music and dance, as well as the visual arts.

These categories are not, of course, rigid. Indeed, part of art's power as a teacher comes from the way it transcends subject boundaries. For example: music often accompanies words in song and we draw to learn in technology and biology. In Chapter 6 we include a child's writing and drawing about death, but it might equally well have been included in Chapter 2, which is on writing. When children reflect on portraits in Chapter 2, the work is relevant to personal, social and moral education (PSME), as well as to English and art.

In the notebooks of Leonardo da Vinci we can see the learning we attribute to art happening very clearly. His notebooks teem with words and images: the foetus, profiles of 'an old man and a youth', anatomical figures 'showing the heart, liver and blood vessels', 'comparison between the legs of a man and a horse'. He also observed with evident fascination 'How a man mounts a step' and 'How a running man stops'. If we were to observe everyday things so carefully we would be more learned individuals. We would also enjoy life more. This would also be true for the children we teach.

Leonardo's drawings show him learning about light and other aspects of the natural world, such as astronomy and acoustics. He worked as a draughtsman to understand, among other things, military engineering, ballistics, hydraulics and bridges. His drawings show him learning about the power of the elements, and about how we might harness them for our own use.

And we list all this without mentioning his obsessive exploration of what he saw as religious truth and falsehood in his paintings of the Holy Family.

That Leonardo was a genius should not hide from us the fact that he was simply insatiably curious: he wanted to know, to get things right. He wanted passionately to understand himself and his world, in that evident but baffling relationship that many of us, much of the

time, shrug off. We give up because, as T S Eliot wrote, 'Humankind cannot bear very much reality'. Education, and art education in particular, is a pure, generous, unrelenting attention to reality and our relationship to it. It is a refusal to shrug. When things happen in our teaching that would deflect our minds and hearts from that attention, we must be wary.

Roger Whiting (1992) says that for Leonardo 'there could be no art without science [and] all aspects of knowledge had to serve each other'. The criss-crossed categories (each rectangle labelled with a subject, science or art or whatever) that we – teachers, administrators, politicians, advisers, inspectors – impose on learning are merely for our temporary convenience. They do not represent any kind of objective reality. Children think holistically, and the world was created and developed holistically. As Clem Adelman puts it in his essay 'The Arts and Young Children':

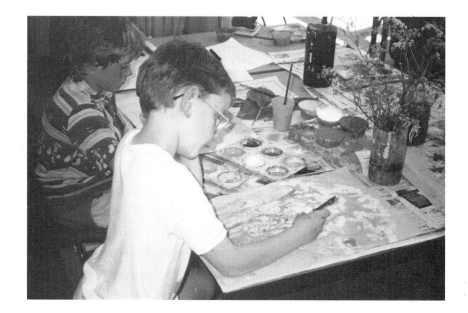

Young children at work, like the artist at work, do not separate . . . their feelings from their thinking and doing. They are integral in their work. It is the teacher who asks the child to split . . . thinking from feeling or doing . . .

Tickle (1987)

Figure 2
Twig by boy aged
eight in pencil

It is only our schooling system which disintegrates the world and our thinking and feeling for it. This book celebrates learning about the whole of creation.

In a small way, most teachers break learning down unnecessarily when they separate drawing from writing. Like Leonardo da Vinci, children, too, can produce pages where drawings and words act together. It is worth thinking about the learning going on in a boy's head as he draws the twig, and writes

**The twig feels like a mountain
It looks like a shrunken tree been struck by lightning
It smells like gun powder**

He is learning about the twig as he examines it carefully enough to make these observations. And he is learning about the power of his language, and its ability to express so clearly what he means.

THE TEACHER AS A LEARNER

A teacher said once 'I don't care what subject it is, as long as they [the children] are learning'. We would ask, why should the teachers not be learning too? What has art to teach us?

We learn when we see ourselves as researchers in our own classrooms, rather than mere deliverers of a prescribed curriculum, mere hired hands doing what we've been told to do. To see ourselves as active learners has implications for our attitudes and behaviour *vis à vis* the managers of education. We must try to ensure that their decisions are educationally motivated; that, in other words, they deal with learning and people, and not merely with the filling in of forms and the saving of money. This means that we take every opportunity offered to participate in those decisions as teachers.

In practical terms, this requires three things. The first is that we have to give generous attention to our practice in the classroom, and to its results in the children's work.

Secondly, we need to write about what we do. We have found it vital to keep a kind of journal to remind ourselves of what has happened, and what the outcomes were. This notion of teachers as writers, of notes, comments, jokes and children's words, will be a recurrent theme throughout this book. As Lawrence Stenhouse says,

in his *Introduction to Curriculum Research and Development*:

> It is not enough that teachers' work should be studied: they need to study it themselves ...

We have found that the indispensable condition of this study is the making of rough notes in the classroom.

Thirdly, we have to be strong and confident enough to share these notes with colleagues in informal meetings. Study is all the more powerful when it takes on the views, advice and support of other professionals.

Through this process – something like action research – we can regain a hold on our practice and become learners alongside the children. It enables us to gain some understanding of the child's view of what learning is, and it provides a strength through solidarity with other teachers. Most importantly, it enables us to make things better, as the cycle of observation, reflection and talk sharpens our focus on what teaching and learning are.

THE WEAKENING OF ART'S ROLE

Art's role as a teacher has been weakened in many ways. Firstly, some have played art down as essentially decorative and ornamental. Look at some nurseries, with their hand-me-down images from Walt Disney or other televised cartoons. Such an environment is implicitly teaching children that the images of the cartoonists, and of Hollywood, are the ones that matter; that such images are more important, more 'right', than whatever images the children make.

Again, some schools concentrate too much on decorative margins. These can be wonderful if seen in the context of medieval manuscripts, or pattern-making, but at worst they can be mere frilly borders. And what does a frilly border signify? Of course, the manner in which work is mounted and displayed is important. It shows respect or otherwise for the children's efforts, and sloppy presentation sends bad messages about how we devalue children's work.

But too great an emphasis on the edges around a product rather than on process expresses a concentration on the surfaces, rather than the substances, of art. We have all seen teachers mount and display work, spending more resources on this essentially secondary activity

than they spent on the materials the child worked with. The mounting of work must be seen to play a positive part by demonstrating to children the value of the project they have undertaken. But anything that can be confidently classified in a classroom as having no learning component can be described as ornament, and therefore as useless.

Secondly, some of us have shoved art to the edge of our lives in schools. Before the National Curriculum, there were some schools that taught practically no art at all. In such places now art is, at worst, little sheets of paper with rudimentary water-based paintings, labelled 'We have been looking at some pictures by Van Gogh'.

But many schools (some of them represented in this book) have always taught art with a sense of its educational power, of what it can be in its own right, and what can be taught through it. We hope that by publicising their potent practice we are spreading good news: this is what art can do.

This book is also for those teachers who feel deskilled by the demands of the National Curriculum; who have concentrated in exemplary and inspiring work on English or science or mathematics, but who feel that art is, perhaps, less relevant than the core subjects. We would like to suggest that art has much to offer, not only aesthetically, but as a teacher of their favourite subjects.

THE LANGUAGE OF ART AND ITS ELEMENTS

The critical elements in art are colour, line, pattern, texture, tone, form and space. In the words of the National Curriculum, pupils should be able to record what has been experienced, observed, imagined and represented in visual form.

We do not have room here to expand on each of these; we suggest, however, that any curriculum design will be more powerful (and more comprehensive) if these ideas are borne constantly in mind.

A NOTE ABOUT QUESTIONS

Much, if not all, effective teaching has happened through the medium of open-ended questions, and throughout this book we

provide suggested questions on each topic. But as teachers, we have often heard ourselves asking useless questions that don't require any serious thought on the part of the child.

The first one quoted here was put, rather aggressively, many years ago, to a child using a magnifying glass to make the sun burn a scrap of paper. 'What do you think you're doing?'

The answer was, in one sense, obvious. 'I'm enjoying myself.' But the child might have answered (to return to the central theme of this introduction) 'I'm learning about how the sun's rays burn things'.

And who is so confident about the nature of learning that they can say that enjoyment isn't part of learning? The question was merely a thinly disguised control mechanism.

Another often useless sort of question isn't really a question at all. 'And these ships are called . . . ?' is merely a check on the teacher's part that a fact has been got across. It is an element in assessment rather than an act of teaching. Assessment and teaching shouldn't be separable, of course, but here they are.

In this book, we have tried to restrict ourselves to questions that lead to thinking. Nearly always, such questions will lead to a period of silence rather than an immediate answer. In classes where the knee-jerk reaction to a teacher's question is a gasp of breath and a hand shot up like a flagpole, something may be wrong. Perhaps there hasn't been any emphasis on thought as a valuable activity. Perhaps the questions tend to be of the second kind mentioned above. In such classrooms, it is possible to encourage thought by insisting on moments of silence (even, perhaps, with eyes closed to aid concentration) before questions are answered.

A NOTE ABOUT EQUIPMENT AND CHOICE

We don't intend to give a list of tools and equipment as they are available in many books, notably in *Art 4–11* (Morgan 1988).

But we would say that children need as wide a variety of basic tools and materials of as good a quality as possible. For example, they require many different mark-making tools: pencils of all strengths; crayons, pastels, brushes, printing equipment and felt tips – those often abused tools that some people talk about as if they were the instruments of the devil ('Oh no, we don't use those things here!').

Problems occur with any of these tools when a certain kind is used to the exclusion of all the others.

One nursery has a drawing area. The teacher told us:

> There is a choice of tools on it. Felt tips are chosen above the others – they're easy to manage and have vivid colours. Anyway, I'm sure children would draw less or even not at all if that table weren't there.

This does not mean that the teacher will not, at times, ask children to experiment with, and use, other tools. Some of the drawings from that table are shown on this page (see figures 3, 4, 5 and 6). There was no adult influence of subject or materials.

Figure 3 *Goose* by boy aged 4 in felt tip pen

Figure 4 *Mother and child* by boy aged four in charcoal

Figure 5 *Cow* by girl aged four in felt tip pen

Figure 6 *Untitled* by boy aged four in felt tip pen

It is clear that there is an enormous confidence in making lines here, and there will be later, in all of these children's experience, a benefit to their writing because of the freedom they have had to draw at four years old. After all, if you can communicate with drawing lines as strong as these when you are four, you are far more likely to make good strong writing lines later on.

Robin Tanner pointed out that choice is a critical component of education: 'Every creative act is an act of choosing' (See *Art 4–11*). This choosing begins with the materials we work with. It is in this choice that the power of art, in its function as a teacher, begins. If we can make this choice real, the others will follow, and the whole world will open, for the children, and for us.

Investigate, make, know. Understand, experience, observe. Record, broaden, extend. Explore, review, reflect. Modify, refine, identify. Express. The words are now familiar to us from the National Curriculum. This book records examples of these activities, and offers suggestions for ways in which these activities can happen in other contexts, helping us all to learn about the subjects that we teach.

2 Art and English

I would paint the first
word ever spoken . . .

child's poem

Of the three core subjects in the National Curriculum, English has the most readily acknowledged connection with art, because several aspects of English – poetry, fiction, drama – are arts in themselves. But there is still much work to be done in understanding the relationship, in making it more explicit, in enriching it, and in suggesting practical examples.

THE RELATIONSHIP: POEMS ABOUT PAINTINGS

The following are some examples of the relationship between art and English. In speaking and listening, we can encourage talk and writing about materials and works of art. Here are some seven-year-olds recorded while working with paint:

These bits of egg box, they make a scratchy mark.
I don't like that, I don't like the streaky holes you get. I like my trusty paint brush [laughter].
The egg box makes my car go faster, look . . .

We can use pictures, models and sculpture as stimuli for writing, and *vice versa*.

A Country Wedding (Pieter Bruegel the Elder)

Oh the noise! the clatter
of plates on tables, the songs,
the jokes, the laughter – the smells

of burning meat, of wax, of
human sweat, of ale spilled, of
coarse wine –

I shuffle along
the floor at Auntie's wedding
and scoff myself nearly sick.

I will snooze through the afternoon
in my father's arms, till I wake
to 'Show me the way to go home'

sung in Dutch by my Uncle Pieter.

We suggest that children should get into the habit of, once or twice a term, looking at a picture, either a reproduction or preferably an original, and then writing poems, stories, reportage, drama or captions. The following are some questions we might ask in order to stimulate this writing:

- What is this person in the picture thinking or saying?
- What is the mood of this picture? Look at the colours and shapes.
- Look at the sky, the sea, the earth. What does it remind you of? What similes and metaphors can you think of? What does it resemble?
- What can you smell, hear, taste in this picture?
- What has happened just around that corner?
- What are these people saying to each other?
- When is this happening?

CHILDREN TALKING ABOUT PICTURES

Sometimes, it is useful for children just to talk to each other and their teacher about pictures and sculptures. A collection of postcard-sized reproductions can be built up with little expense. We would suggest that, as teachers, we might usefully record some of the remarks children make while looking at pictures.

The following questions and others like them will stimulate both talk (and, by the same token, listening) and writing:

- What's going on in this picture?
- Who are these people, what are these things?
- Why do you think the artist chose this subject? This colour? This time?
- What does this colour remind you of?
- How is this person getting on? What do you think is in her mind?
- Can you imagine the noise you might hear in this scene?
- Can you imagine the smells you might smell? The tastes you might taste?
- What is the strangest thing going on in this picture?
- What feeling does this picture convey?
- Look at shapes, lines, tones and colours – what techniques has the artist used to convey these feelings?

Five children, all aged ten or eleven, discussed the following pictures: the original of *Girl in a straw hat*, by Freda Downie (1929–1993) (see figure C2 on page 113); *William Cowper*, by George Romney (1734–1802), which is on the cover of *Master Drawings from the National Portrait Gallery*; *Whaam!* by Roy Lichtenstein (1923–) and *Full Fathom Five* by Jackson Pollock (1912–1956), both of which are reproduced in *A Gallery of Masterpieces* (Phaidon 1974); and two canvases by John Hoyland, *Nagas* (1991) and *Kings Seal* (1993), (both reproduced in *Modern Painters* Spring 1994.)

What follows is part of the transcript of the children's remarks. They began by looking at the Downie:

> She is thinking of something grotty. She's got a lot of expressions, but none of them happy. She's posh and droopy . . . She's going to a wedding but she doesn't know how to celebrate . . . Her boyfriend's gone on the train. She's got a child. She's down in the dumps. He's gone to war. The eyes show the sadness, don't they? They're tearful. They're blurry. They're open in a funny way. The blue from the reflection in her face makes her look cool and sad. She's uptight. If someone talked to her she'd snap

their head off. If you could hear the noises in this picture, you would hear the chugging of the train, the silence, the breathing. She wants to cry, but not in front of the child. She wants to curl up in a ball and die.

On the Cowper portrait:

He looks as though he knows something you don't know. He's nutty! His eyes are wide. They're staring. They're devious. No they're not! They're just full of looniness!

On the Pollock (we didn't tell the group the title of this picture):

There's leaves and branches together in a big huddle. There's a crocodile! It looks like the sea in a storm. There's a skull! A head! Yeah! If you stare at it, you imagine things that you want to see. If you want to see a rabbit, you see a rabbit. Was this painter a bit iffy, you know, a bit mad! It looks like they couldn't paint, so they just splashed it on – No, it takes talent to paint like that. If you listened you would hear fireworks, you'd hear space, whizzing. It's all angry, dark colours, it looks like a thornbush with those angry, jagged colours . . .

On the Hoylands:

What are they? Are they cave paintings? They're like that writing, you know . . . Yeah, hieroglyphics. They're like a constellation in space. They're powerful. But I don't like them (unanimous). Well, I don't know (Lamehl changing his mind, slightly) I think I do like them, but no, I certainly wouldn't want them on my wall.

On the Lichtenstein:

This isn't art, it's just a comic strip. (Can't art be a comic strip? Can't a comic strip be art? – D&FS) Yeah, the Beano can, but not this. Just rockets. Naah. We don't like this one. It's too silly to be a picture. The expression on

that one's face (Freda Downie's painting) is telling you
more than *Whaam!*

It is startling to see how quickly the children homed in on the
psychological truth behind the Cowper portrait – his madness. In
their remarks on the Downie, they accept an opportunity to reflect on
human predicaments, some of which are not, of course, so far from
their own and their parents' experiences:

> Her boyfriend's gone on the train. She's got a child. She's
> down in the dumps. The eyes show the sadness, don't
> they? They're tearful. They're blurry. They're open in a
> funny way. She's uptight. If someone talked to her she'd
> snap their head off. She wants to cry, but not in front of
> the child. She wants to curl up in a ball and die.

In this conversation, the children are sharing a rich personal and
social experience. They are using their language, through the catalyst
of pictures, to move towards a greater understanding of what it is to
be a human being.

The children have explored aspects of English in their talk. Slowly
they have built a wordhoard or database of expressions for sadness:
'down in the dumps . . . The eyes show the sadness . . . cool and sad
. . . She's uptight'. All this grows remarkably quickly – within seconds,
in fact – from the weaker expression 'grotty'. Occasionally they
produce remarkable little sequences, bouncing ideas off each other:

> the chugging of the train, the silence, the breathing. She
> wants to cry, but not in front of the child. She wants to
> curl up in a ball and die.

Also, these pupils respond well to the opportunity to play with words
that are quite difficult, but which they have probably heard in a
different context: 'hieroglyphics', 'constellation' and 'devious'.

They have also reflected to some purpose on the techniques used
in the pictures ('the blue from the reflection in her face makes her
look cool and sad'). But above all, we are impressed with how daring
their remarks are. They have no problem talking about madness and
suffering without using the prissy language of adults. They are also

very open (except, surprisingly perhaps, in the case of *Whaam!*) to modern art, compared to many adults.

Tasks we might set include asking children to write as if they were a character in the scene; or asking them to talk to one of the characters. We might also ask the pupils to write a dialogue between two characters in a picture, and then to perform it; or perhaps to write a story leading up to the moment depicted in the picture. The children might perform the dialogue they had composed.

MAKING ART WITH WRITING AS A STIMULUS

There are many familiar passages in literature for children which would make good stimuli for painting, drawing and model-making. We might look at the current novel we are reading for strongly visual paragraphs. William Blake's 'The Tyger' is an obvious stimulus for such work, but there are many others, such as paintings by Henri Rousseau.

Here is a poem by Fred Sedgwick, 'Tomorrow I'm going to the fair', from his book *Hey!* (with John Cotton, Mary Glasgow 1990), which was used as a starting point for discussion:

> Tomorrow I'm going to the fair.
> The others in our class'll be there,
> coins stuffed into anoraks,
> crashing round the dodgem tracks.
>
> Tomorrow I'm going to the fair.
> Jessica Jackson-Wood'll be there
> on the Flying Rolletto as high as high
> while her mother squints at the terrible sky.
>
> The boys from Inkerman Street will be in
> the Ghost Train making a ghostly din.
> They'll suck on candy floss, and smoke,
> and go home loud and happy and broke.
>
> Tomorrow I'm going to the fair.
> There's nothing on earth that can compare
> with the raucous light, and the flashing sound,
> as Jessie and I whirl the dodgems around.

Here are some questions we might ask after children have heard and (preferably) read this poem:

- Can you paint the Flying Rolletto, and make it look scary with colour and line?
- Can you make it look as if it's moving?
- What angle are you going to paint it from?
- Can you paint Jessie's mother's face, with her frightened expression?
- Can you paint the boys from Inkerman Street, and make them look noisy?
- Can you make the light look raucous?
- Can you paint a flashing sound?

WRITING POETRY IN THE NURSERY

Here is an example of nursery children composing a poem:

Figure 7
'This man is smoking a pipe' by a girl aged four in felt tip pen

This man

This man is smoking a pipe.
He is heavy and tall
with strong legs
and square crinkly feet.

His hands are flat.
One hand is holding the pipe.
He has a bit of hair
sticking up on the top – like a handle.

His eyes are like lemons,
like leaves.
There are diamonds in his eyes.

His nose is a sharp triangle
like an eagle's beak.
He is standing on a bar of soap,
on a brick.
This man is smoking a pipe.

The children have made this poem with the help of questioning from the teacher. It is not hard for us to infer what the questions were: they led to lively simile ('His eyes are like lemons,/like leaves'; 'He has a bit of hair/standing up on top – like a handle') as well as some other vivid images, such as the diamonds in his eyes.

As well as the teacher's questions there was another stimulus for this work; a work of art, an African statuette which one of the children has drawn so that it looks more like a Giacometti sculpture than anything else. And, of course, Giacometti must have been influenced by similar sculptures.

In the same nursery the teacher used the stimulus of a display of silver art objects and junk (not illustrated here) to get children talking. She wrote down what they said. Extracts from the list reveal the richness of language available to young children, and also the variety of their cultural heritage. 'Can you' the teacher said 'think of any more shiny things?':

> The sun, a rainbow, the moon, fireworks, stars, saris, lightning, candles, gold things, sequins, glitter, Layna's ring, a shiny waterproof coat, Ellie's Mum's ring, Mrs Sedgwick's earrings, a knife, a spoon, the buttons on Rhys's dungarees, Grandad's car when it's been washed, when your hair is washed it shines, Charlotte's sister's plastic bib, Derek's metal Indian, Jahanara's bangles, Aladdin's lamp, a new exhaust on a car, a box of rings . . .

This list was written on a piece of display paper quickly by the teacher as the children gave her the words. This showed that words are concerned with communication, not with looking pretty: that we communicate in a hurry, and as a priority; that writing is an important and essential human activity.

DRAWING AND WRITING ABOUT ANIMALS: AN EXAMPLE

For some reason, cats have often helped poets produce lively poems. All the following work could have fitted equally well in Chapter 2, because it is about observation of scientific phenomena.

Leonardo da Vinci looked at a cat, and wrote:

If at night your eye is placed between the light and the eye of a cat, it will see the eye look like fire. (*Notebooks*)

Figure 8 *Cat* by boy aged eleven in pencil

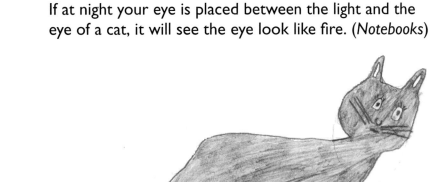

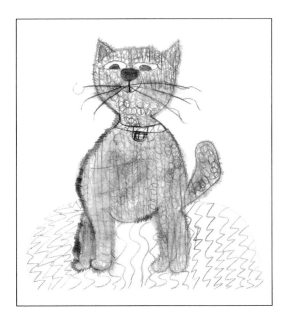

Figure 9 *Cat* by girl aged eleven in pencil

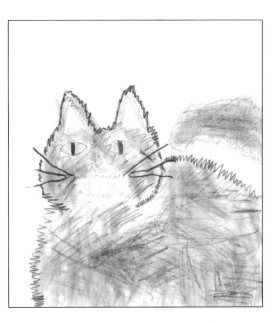

Figure 10 *Cat* by boy aged eleven in pencil

Figures 8, 9 and 10 were done as part of a drawing lesson and preceded the writing which follows them. The teacher had given the children scraps of paper, and had asked them to fill them in 'with as many different kinds of pencil mark as you can think of'. What follows is an account of the drawing session.

This is what the teacher said to these ten and eleven year olds:

> Close your eyes. I want you to think about a cat. Not just any cat; a cat you know. Maybe it's your cat, or the cat from down the road. Or your aunt's cat, or your grandma's cat. Or some wild cat you've glimpsed somewhere, sometime. Now use your mind's eye, the eye in your head, to look at the cat. At the patterns on its fur. At the way it moves. At its eyes, its whiskers. Look at its tongue as it drinks. Let it lick your hand; what does its tongue feel like?

There are other questions like these that the teacher might have used. All of them are followed by a pause for thought, and many of these pauses are quite long. This teacher believes – rightly, in our view – that children are often not given sufficient time for thinking in many of our schools. We believe that as teachers, we might find ways of helping children to reflect, think, even meditate, before, during and after work in any subject.

The atmosphere in the room is tense. This is because children readily believe in the idea of the mind's eye and because cats are familiar to them. The quality of the concentration and thought that the teacher has elicited from them is such that they readily accept the instruction 'Keep looking at the cat'.

There have been two components in the lesson so far: technical play with the pencils, and an imaginative study of the cat. Now the teacher introduces two more components.

> I want you to draw the cat you've been looking at in your mind; but I don't want it far away and in the distance. I want it close up, so I can see every detail.

> And I want you to keep looking at the cat as you draw.

He then reminds the children of the different pencil marks they made at the beginning of the lesson, and about their minds' eyes. And he asks them to draw the cat.

We notice the power, focus and definition of these drawings. The children are not following a Tom and Jerry stereotype, but are

producing work that is evidently their own. We also notice the depth and vigour the pencil play has brought to the work, and the way the characters of the cats have emerged: prim, raddled, sly, wicked, cuddly, nervous, tentative.

The writing is equally strong (these are from a similar session in a different school):

> The cat's eyes are olive-green, the shape is like a kiwi fruit. The fur tickles me like a feather. It feels so nice it's like I'm going to go to sleep. The cat walks slowly and quietly like an Indian searching for food.
>
> The fur felt like a carpet on your leg with bits of wet fur on it. It strides like a Siamese, as if it were the most important person in the world. It curled up with its head under its lap like an old football with a dangly bit. The tongue curled up like a ball.

One piece of writing ended with a remarkable hint at a pun:

> The tongue drinks up all the milk like a racing car, lap after lap after lap

Figure 11 shows a cat poem written by a boy on a word processor.

Figure 11　Cat poem by boy aged 7, word processor

CAT

The cat's eyes have got lines in them around the eye ball.
The cat's eyes are looking hopeful.

The cat's fur is ginger and white.
It reminds me of Saturn.
Look closely it looks mysterious.

The cat's fur is smooth and sleek.

When the cat is about to pounce it walks very slowly
and then stops.
And as quick as a flash of lightning speed it pounces.

Then the cat comes back in and curls up.
It looks like a snail's shell.

The cat starts drinking milk and it laps it up.
The pink tongue darts out like a snake's tongue.

A CHILD'S POEM ABOUT ART

We supply children with various stimuli for writing and making visual art as often as time allows. The more children have the making of art as a habit, the more things like this are likely to occur. Look at the poem at the beginning of Chapter 1 on page 15. It is not there to represent great writing, but to demonstrate the way that it has enabled learning. Look how the child's search for form and rhyme leads her through a delightfully appropriate adjective ('sly') to a reflective conclusion she will, given the opportunity, build on. She has asked herself an important question.

The poem in figure 12 makes explicit the connection between visual art and English. Following an idea by John Cotton (see his excellent *Poetry File* (1989) this girl imagined she could paint whatever she wanted – even impossible things:

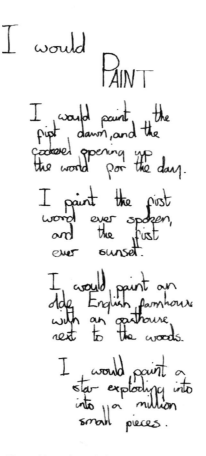

Figure 12 *'I would paint'* by girl aged eleven

WORDS AND PICTURES WORKING TOGETHER

It is important to show children how, in many texts, words and illustrations have equal status. Most children grow up knowing books like Maurice Sendak's *Where the Wild Things Are*, and most classrooms offer children everyday experiences with texts like these. The best of such books – David McKee's *Not Now Bernard*, Alice Walker's *To Hell with Dying*, anything by Helen Oxenbury and John Burningham, the disquieting books of Anthony Browne – are not merely decorative, either in text or visually, but address serious issues such as family disagreements, love and death, bullying and forgiveness. Indeed, Browne himself has written (Morag Styles *et al.* 1994)

> Although I write and illustrate books, I don't think of it as writing a story and then illustrating it or indeed, illustrating some pictures and then writing a story around it – those are the worst ways to do a book. The two things come very much together for me.

Older primary children can write and make art for such texts themselves. They need to be focused on an audience, and it is useful to offer them the youngest children in the school as that audience.

Later, the two classes might meet in a comfortable setting, with scatter cushions and orange squash. The learning isn't just about language, as the older children read and the younger ones listen and talk. It's about personal and social issues. It's also about how we meet unfamiliar people, and build bridges with them.

In his book *A Book of One's Own* Paul Johnson shows with many powerful examples how children use visual images on the page alongside words in order to communicate their learning. They draw and write with vigour 'for the attainment of creative power', as Irma Richter puts it (1980).

An art inspector said to one of us years ago 'There is much beautiful drawing in your school . . . and there is much wonderful writing, too . . . But why do you always separate the two?' It made us think, and we have continued thinking about this artificial dichotomy. Many books in our culture do not use visual images. Novels, for example, very rarely do. Other books use visual images for

illustration. This is frequently the case with poetry anthologies for children, where little drawings adorn the edges of pages, an inferior position in relation to the words. Arguably, the most powerful educational books use pictures and words as equal partners in the quest to teach. One thinks of *Mr Magnolia* by Quentin Blake, or the excellent range of Dorling Kindersley Eyewitness Guides.

A NOTE ABOUT HANDWRITING

All artistic activities that are designed with care encourage and help develop confidence and ability in hand control. This assists handwriting. What we might call a deficit model – 'The handwriting in this school is terrible – let's make it better' is unsound, as deficit models are in all educational areas.

It is far better to offer children a stimulating environment, efficient, exciting tools and inspiring stimuli. Children who have frequent experiences with a wide variety of graphic tools from an early age are likely to have a pleasing and readable handwriting style when they are older. On the other hand, those whose drawing is rare, erratic, and done with poor materials will always be at a disadvantage.

The child with the vivid artistic experiences is also more likely to be conscious of the rhythm and flow of a pencil or pen, and this is as important for presentation as it is for art.

3 Art and science

It was not only the beauty of nature but also the spirit at work beneath the world of appearance that fascinated him.

Irma Richter on Leonardo da Vinci (da Vinci 1980)

Observe the goose's foot . . .

Leonardo da Vinci

SCIENCE, ART AND OBSERVATION

We believe that the notion that there is a gulf fixed between science and art is a sentimental delusion fostered by philistines on both sides of the imaginary divide. We are not the first to say so either as Herbert Read wrote in 1943:

> . . . I do not distinguish science and art, except as methods, and I believe that the opposition created between them in the past has been due to a limited view of both activities. Art is the representation, science the explanation – of the same reality.

The first principle of both science and art is observation. Figure 13 shows how a ten-year-old has looked with exemplary attention to make this weaving of the inside of a halved cabbage.

Wynne Harlen, a leading writer on science education, would agree with Read. In *Science in the Primary School* she says 'Science is about understanding the real world around'. You can't hypothesise or create, or understand, unless you've looked (and, come to that, listened, smelt, touched, tasted) and responded with an open mind.

We only have to think of photographs of microscopically small matter, of human embryos, of the most distant stars in our galaxy, to see how poetic science can be. And those of us who were turned off science while at school have a reasonable grudge to bear against our

teachers: not only for depriving us of science, but for depriving us of elements of beauty that would have made our art, or our poetry, the stronger.

Figure 13 *Inside of a cabbage* by girl aged nine, sewing

CHILDREN AS ACTIVE LEARNERS

There is, in all views of learning, a tension between those who see education as pre-eminently a handing down of cultural traditions (embodied, for the time being, presumably, in the National Curriculum's statements of attainment) and those who see all learners, both children and adults, as active: taking part, as Wynne Harlen puts it, 'in constructing the knowledge rather than receiving it ready-made from someone else'; or, in Leonardo da Vinci's terms, having an *experience.*

While it is clear that children who miss elements in their cultural tradition are intellectually disadvantaged, we use in this book a model of the learner as an *active* learner. In making art as they learn about, for example, the inside of the human body, or the inside of a car engine, children actively respond to the subject being taught, or 'handed down'. The experience also helps children investigate causes. It helps them make their tradition their own.

Merely to take on culture uncritically would be to be craft-*trained* in the poorest sense of the word. To be *educated*, on the other hand, we must be active and alert. That attention is not passive, but constantly awake, and potentially subversive and risky. It is open and active. Rooted in the tradition, it moves forward out of it.

Art enables children to research the world by drawing and modelling, and thus shares a central aim with science. As Rod Taylor and Glennis Andrews put it in *The Arts in the Primary School* (1993)

Properly taught, both the arts and the sciences engage children in the full use of their senses . . .

However, as they then point out, the National Curriculum has led to the dominance of science, and the marginalisation of art. As active teachers, writing about our experiences and talking about them with colleagues, we resist this tendency. We push art back to its central place in education.

All the work in this chapter shows evidence of children looking with an intensity that is almost the prerequisite for all learning.

LEARNING ABOUT THE HUMAN BODY

These eight-year-old children have been following a topic called 'My body'. Although as a topic this has the benefit of the constant presence of first-hand experience, it is surprising that sometimes we teach it almost entirely through books. This teacher used the class's PE lessons to look at movement and to achieve these vivid drawings shown in figures 14a and 14b. She told us:

After warming up, half the class watched and drew pencil sketches of the others on the apparatus. Then we switched over. Back in the class, we used the sketches as

the basis for our felt pen drawings (no pencil allowed on this occasion, which seemed to result in much thought and planning before they started). Children posed again for each other if they were uncertain about limb positions.

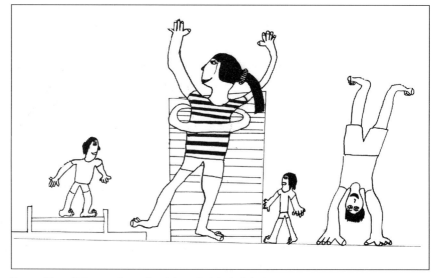

Figure 14a *Apparatus lesson* by girl aged eight in felt tip pen

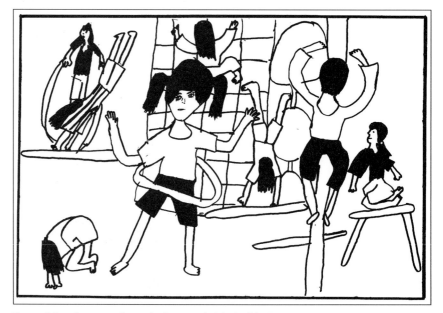

Figure 14b *Apparatus lesson* by boy aged eight in felt tip pen

This raises an important point about graphic tools. They teach different things in different ways. For example, for initial sketching on site – perhaps in a street, or in a park, or at a zoo – children need pencils, so that the provisional (what they often call 'wrong') lines don't dominate. On the other hand, felt tip pens are useful when we want the children to concentrate on planning.

When using pencils (of all strengths) it is worth freeing children from the tyranny of the eraser. The fact that some children are obsessive about their collection of these negative little slabs is evidence, in part, of a perceived need for photographic accuracy, as though this kind of accuracy is as important as feeling and learning; which, of course, it isn't. A concern for photographic accuracy did not trouble artists like Giotto when issues of emotion and truth were their concerns.

Another class of children, this time 10- and 11-year-olds, were working on the human body. It will be obvious from the work that the observations were of secondary source material: excellent books, cardboard models of the human body and so on. The children made models of, for example, the digestive system inside A4 paper boxes, and wrote these 'kennings'. A kenning is a Norse way of writing which uses a new descriptive name, usually two words, based on an attribute of the original; for example, 'swan's way' for the sea. (See C3 on page 114.)

The children are learning in three fields in one topic: art, science and English:

Heart

A hard beater
A blood pumper
A body saver
A mayhem maker
A message receiver
A body needer
A squidgy ball
A big red drum
A great red sponge
A death attack

Figure 15 *Large intestine*, illustrated poem by girl aged ten

Large intestine

A great food carriage.

A squashy slide.
A dark, pink tunnel
A loop of fat
A mixed up junction.

A spaghetti bolognaise
A squidgy slime
A squashy sandwich spread.
A squelchy squish
A long train going round a corner
A slinky slush
A silky sheet
A muddly shoe lace
A gungy goo
A squashy string
A scary twisting roller coaster.
A gigantic runner bean.
A great pink blob.

by
Kachel
Reeve.

These poems display a necessary zest for language: there is a sense of fun, and an awareness of the value of sounds.

But as well as this, there is an awareness of the primary functions of the heart and the long intestine. The learning in the three areas moves forward together, and the areas feed each other, and off each other.

LEARNING ABOUT ANIMALS AND PLANTS

As we have seen in Chapter 2, art is a powerful way of beginning to understand wildlife. Indeed, it is a moot point whether bird artists, for example, are artists or ornithologists. Watching an expert drawing a bird, few would disagree that the expert was engaged in an artistic activity. But the scientific learning, as the eyes examine and the paintbrush moves, is almost palpable.

The children who drew Figures 16a and 16b had received a visit from a man who had shown them twelve birds of prey on the field. The children's attention was complete as they watched the birds flying and standing; as they'd examined close up the eyes, feathers and talons. They reminded us of the sheer care, the curiousness, the need to *know* that we can study in a note of Leonardo da Vinci:

> **Observe the goose's foot: if it were always open or always closed the creature would not be able to make any kind of movement. While with the curve of the foot outwards it has more perception of the water in going forward than the foot would have as it is drawn back; this shows the same weight the wider it is the slower is its movement . . .**

We are concerned with children, and to encourage this level of observation in them is a professional duty as well as a pleasure and a thrill. Later, the children found pictures of owls in a reference book and made these pictures with black ink.

Figure 16a *Owl by girl aged ten in pen and ink*

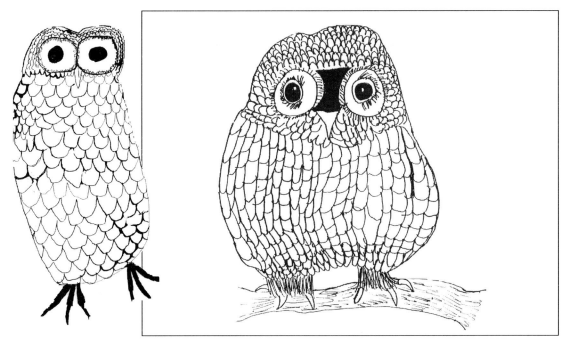

Figure 16b *Owl by girl aged ten in pen and ink*

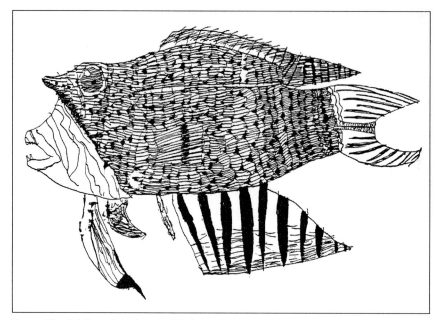

Figure 17 *Fish* by girl aged ten in black ink

Other children were studying fish, and, though they had looked closely at fish in an aquarium, this drawing was also derived from books (figure 17). This suggests that, although the conventional wisdom is correct that says that children draw best from first-hand objects, photographs can also be useful once the children have had the first-hand experience.

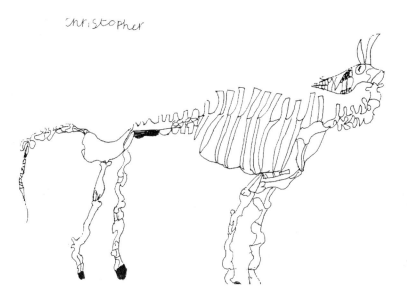

Figure 18 *Skeleton* by
boy aged ten in black ink

The children drawing the skeletons were, on the other hand, looking at real skeletons (figure 18). This is always the better way. See also the sheep's skull drawn in a nursery (figure 19).

Art also helps us to appreciate both the beauty and the working of flora, as well as fauna. The child who made figure 20 worked from a photograph, where she isolated a section, drew it with a pencil, and made a weaving. These children were fortunate that, although their school and homes were situated in the middle of a new town, the playground abutted on to woods. (See C4 and C5 on page 115.)

Figure 19
Sheep's skull
by girl aged
four in pencil

Figure 20 *Woods* by girl aged nine, weaving

The teacher writes, in the book containing the children's work, some words of Robert Frost's:

> Our woods *are* lovely, dark and deep. Cool in the heat of summer, providing shade during the long lunchtime break; vibrant during the autumn, providing soft warm leaves for making dens and camps; striking during the winter, offering dark shapes and shadows in which to hide and play; beautiful, cool and fresh in the spring, when bright green leaves stretch from the knees to the sky, and bluebells smother the ground . . .

We have mentioned the importance of teachers themselves writing. Scribing what the children say is one example. Another is keeping a log about how the work of the classroom is progressing. This teacher wrote about their project at length, and again she is showing children the importance of writing by doing it herself. With such an example, it is not surprising that these children write with such confidence. One April, for example, a child composed this poem within her drawing of a leaf:

> Holes
> of light gaze
> through the trees
> like sparkling pearls
> shining in the sun.
> The air's cold, damp and fresh.
> When you look up you see
> diamond shaped leaves bright
> sparkling crinkled leaves.
> Colours of the wood green,
> yellow and rusty brown.

This work included a computer printout showing a weekly record of day and night temperatures, windspeed, wind direction, rainfall, daylight hours and phases of the moon (figure 21).

Y5 kept a weekly record of day and night temperatures, windspeed, wind direction, rainfall, daylight hours and phases of the moon

File: CLIMATE

DAY	Day temp	Night temp	Day windsp	Nt wind sp
SEPT 7TH 1993	20 deg	13 deg	25	20
SEPT 14TH 1993	16 deg	10 deg	20	15
SEPT 21ST 1993	19 deg	11 deg	15	15
SEPT.28TH.1993	14 deg	9 deg	15	15
OCT.5TH.1993	14 deg	9 deg	30	25
OCT.12TH 1993	15 deg	10 deg	15	10
OCT 19 1993	10 deg	-1 deg	15	10
OCT.26TH 1993	11 deg	5 deg	20	15
NOV.2ND 1993	9 deg	8 deg	15	15
NOV.9TH 1993	11 deg	5 deg	20	30
NOV.16TH 1993	9 deg	-1 deg	10	10
NOV.23 .1993	2 deg	-5 deg	10	5
NOV.30TH 1993	7 deg	1 deg	10	10
DEC.7TH 1993	6 deg	1 deg	20	20
DEC.14TH 1993	5 deg	3 deg	20	35
DEC.21ST.1993	6 deg	0 deg	30	20
DEC.28TH 1993	4 deg	3 deg	25	20
JAN.4TH 1994	6 deg	0 deg	20	25
JAN.11TH 1994	8 deg	4 deg	15	15
JAN.18TH 1994	4. deg	6 deg	20	30
JAN.25TH 1994	8 deg	2 deg	30	30
FEB.1ST 1994	10 deg	3 deg	35	20
FEB.8TH 1994	8 deg	3 deg	25	20
FEB.15TH 1994	3 deg	-1 deg	20	10
FEB.22ND 1994	3 deg	0 deg	15	15
MARCH 1ST 1994	9 deg	6 deg	15	20
MARCH 8TH 1994	13 deg	9 deg	25	25
MARCH 15TH1994	9 deg	0 deg	35	30
MARCH 22ND1994	14 deg	9 deg	25	25
29THMARCH 1994	13 deg	3 deg	15	15
APRIL 5TH 1994	9 deg	4 deg	25	15
APRIL12TH 1994	11 deg	5 deg	15	10
APRIL19TH 1994	12 deg	6 deg	5	5
APRIL26TH 1994	16 deg	10 deg	25	20
MAY 3RD 1994	15 deg	8 deg	20	25
MAY 10TH 1994	17 deg	7 deg	15	15
MAY 17TH 1994	17 deg	11 deg	10	10
27TH MAY 1994	14 deg	8 deg	5	5
MAY 31ST 1994	20 deg	10 deg	10	10
JUNE 7TH 1994	18 deg	10 deg	15	10
JUNE 14TH 1994	22 deg	10 deg	10	10
JUNE 21ST 1994	20 deg	16 deg	20	25
JUNE 28TH 1994	26 deg	15 deg	5	5
JULY.5TH.1994	21 deg	9 deg	20	20

DAY	Day wind d	Nt wind d	Day rain	Night rain
SEPT 7TH 1993	S:E:	S	NONE	SHOWR
SEPT 14TH 1993	N.W.	N.W.	WET	WET
SEPT 21ST 1993	S W	S W	SHOWERS	NONE

Figure 21 *Temperature chart* by whole class, computer printout

In this project, the children were learning about art – in several forms, including photography, as well as the more familiar drawing, weaving and painting; language, in discussion, writing and reading each others' contributions; and, of course, about science, as they examined to some serious purpose their natural environment. They were also learning mathematics as they measured the girth and heights of trees.

We can see a similarly rich mixture in this little page of work (previously reproduced in *Art 4–11* (Morgan, 1988)) showing a ten-year-old boy learning about the buds of a purple lilac tree (figure 22). This arose from a project on plants. The teacher had taken the children of an urban primary school round some unusually rich grounds which contained silver birches, hydrangeas, rhododendrons, roses, and fir trees.

He had told the children:

> Here is a piece of paper, a clipboard and a pencil. I want you to find one plant in the grounds, and use those three things to learn about it.

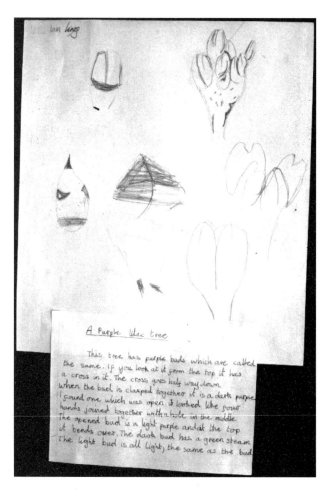

Figure 22 *Lilac buds* by boy aged ten in pencil and writing

A LITTLE ENVIRONMENT

A ten-year-old boy was given a worksheet by his teacher:

Can you find a wall which is crumbling and falling down, is full of different colours, has roots of plants in it, has things stuck to it and growing on it and has areas of plaster and brick? . . . Using your sketchbook to record information, select from the tasks below.

- What words can you use to describe your wall?
- Take some photographs of the wall . . .
- Write down everything you see in a small section of the wall.
- Place a small viewfinder (about 10cm by 10cm) on an interesting part of the wall. Record what you see in line. Record what you see in colour . . .

This boy made a delicate line drawing in his sketchbook, and then another using colour pencils. His painting and his material collage are reproduced in the colour section, C6 and C7 (page 116). He told us:

We had to find some little environments on bricks. Then we got a viewfinder and we did a line drawing of them, and a colour drawing. We used made surfaces, and sprayed on them with a diffuser, and did some marbling . . . and we used found surfaces, and we got materials from a box and stuck that on. It was good fun . . . When we'd finished the painting, we touched it up with oil pastels. We did the collage with a sewing machine. I'd never used one before.

This carefully planned experience emphasises the richness of the processes through which the children went, rather than the end product. We note the quality of the boy's language ('little environments on bricks'); the variety of artistic techniques he has used; the pleasure he has had in his work; and the fact that he has had

at least one experience – using a sewing machine – he had never had before. He also had the opportunity to research in books, finding the names of plants and insects.

A nursery child has drawn in large scale (her picture is a metre in length) a tree root friends had found (figure 23).

Figure 23 *Tree root* by girl aged four

LOOKING AT MACHINES

The children who drew cars shown in figures 24, 25 and 26 are five years old. Before they were given the chance to draw, they looked in the engine of the car; they listened to it as it ran, and smelt it; they noticed how, as one of them said, it 'shivered'; they crowded into the front and back seats ('How many of us do you think will be able to get into this car?'). They talked about it while they sat in it, in response to the teacher's questions. He wrote down what they said, and shaped it, with them, into a poem:

Figure 24 *Car* by girl aged five in pencil

Figure 25 *Car* by girl aged five in pencil

Figure 26 *Part of engine* by boy aged five in pencil

The Car

It reminds me of a digger,
that bike we talked about,
a motor bike, a gun shooting,
a ski boat.
I can see a circle.
The belt is going fast
like a fan, a bulldozer.
There's tapping music, like drums.
Rock 'n' roll music.
There's quiet as silence,
quiet as a bunny rabbit.
It smells oily, like petrol,
burning steam. Gas. Smoke.
Inside it smells of perfume and dust,
It's like a house that can move.
The windows open like magic,
like jumping frogs.
The glass moves up
It's light like – a light!
like the sun.
A square, fresh air.
It's grey as a grey fox.

We've already said, we do not need to help children to reproduce what they see with photographic accuracy. What matters is that all children will draw and talk vigorously and accurately if we enable and expect them to.

Compare Emily's Nissan with a conventional child's drawing of a car. It has strength and an unconventional feel to it. As she drew, the teacher was talking to her:

> Look at the bonnet. How is it held up?
>
> How does the door open? Can you draw that?
>
> How many windows are there? What are the shapes of them?
>
> Can you look closely at the tyres, and draw how they look?

The poem is, of course a first draft – a phrase we can use at times like this, to make the idea of the provisionality of most of our notes part of the tradition of the classroom. The teacher helped here, again, by not being precious about his handwriting in his journal, or in the notes he made as the children composed their poems. He used his pen quickly, to get things down before he forgot them. He said, half to himself, 'Maybe I'll write that up again later . . .'

This point about writing quickly is allied to the point we made in the introduction about frilly borders. Learning involves something more important than the elegance of a handwriting style or a decorative pattern. Children need a crisp, legible hand to get down their responses to the stimuli we offer them, not mannered italic. For those concerned with teaching handwriting, see Chapter 9 of *Art 4–11*, (Morgan 1988).

An 11-year-old boy spent half an hour looking into the running engine of his teacher's car before writing this poem:

> An elephant's trunk withdraws from an ice bucket.
> The elephant is very gritty.
> Four grass snakes crawl into a cardboard box.
> When he revs the car up, the snakes nearly knock the box over.

When the engine is turned on, the snakes were
frightened.
They were shaking.
There was a dead snake at the back.
His head had been burnt off.

The teacher who is also a writer-researcher might ask herself certain
questions after teaching this boy and reading his poem. Those
questions are about learning:

- What language development can we identify here?
- What experience in observation and recording can we identify?
- How might we push the learning forward? We might, for
 example, drop a hint that there are other animals under that
 bonnet. We might ask the writer questions about the pieces
 of engine he has compared to elephant's trunks and snakes.
 What are they really? What are they for? How did they get
 there? What do you think they are made of? Why are they
 made of that, and not of something else?

WRITING ABOUT LIGHT

Light poem

Reflecting ruler shapes of light,
Dazzling long pieces of string.

It's a burning sparkle,
Flooding gushes of gold.

Rolling, dull cottonwool,
Allowing its magic dust to brighten the sky.

Long streaks of golden hair,
Flowing down from heavenly, fluffy heads.

Falling, falling between walls of lost light,
Can't find its way through my mind.

Sparkling twinkles of stars,
Burning my eyes, reflecting my dreams.

In this work, English, science and art come together, as they do in life, assuming we can shake off our decompartmentalising habits.

COLLECTIONS

This is a useful theme for teaching both art and science. Children, of course, are passionate collectors, and one teacher made the most of this. Rosie has represented her shell in four different media – pencil, collage, print and paint. So, she is a collector of media and tools as well as of shells. See C8, C9 and C10, on pages 117–18.

ART AND SCIENCE

There are many ways in which art and science work together. Here are some for which we have not provided examples:

- Sound and music
- Earth, atmosphere and weather
- Colour mixing (which helps children explore the differences between, on the one hand, colour in terms of *light* and, on the other, colour in terms of *pigment*)
- Rainbows and cloud patterns (note that much of John Constable's work as an artist began as scientific studies of clouds)
- Experiments: for example, spirals with salt (in this experiment, children fill a washing up liquid bottle with salt, suspend it upside down over black paper and watch the effect as the bottle swings. They can then compare results, as the salt pours out, with images of galaxies).
- Looking at telescopic photographs of moments in the life of the universe, and microscopic ones of blood cells.

Other suggestions for art's teaching role in scientific projects involve exploring plants and animals; looking at animal products such as honeycombs and nests. Here, science, maths and art all can be seen to come together. Children can look at patterns of seeds inside oranges, tomatoes and peppers.

A project on the garden involves art and botany (this last subject, with symmetry and patterns in flowers, also offers the elegance of mathematics). Close observation and hypothesising constantly link art and science. Although, as Irma Richter says:

> the painter's eye sees but the surface of things, it must in rendering the surface discern and interpret the structure that lies beneath.

This goes for the plants that children examine in order to draw, and to close observation of all scientific phenomena. Roger Whiting tells us that Leonardo da Vinci drew plants and flowers throughout his life:

- as studies for paintings
- in his formal scientific studies
- in his unremitting quest to understand the principles and systems that underlay all living things.

There are three noble aims, and not a whit out of date or out of place in today's classrooms.

SOME NOTES ON TECHNOLOGY

The National Curriculum exhorts us to make sure that children 'explore and use a variety of materials'. In art, as long as their experience of tools is wide and varied, children are engaging in technological activity. Art ensures that children (to quote the National Curriculum again) 'recognise that many materials are available and have different characteristics'. They also should recognise aesthetic qualities in things around them by observation and recording, and 'use drawings to develop ideas'.

As children draw and make models in the act of designing, they solve problems concerned with both the task in hand and their materials. They think, reform and refine. All this can be seen in a project on building that had elements in English, art, science and technology (see C11, C12, C13, pages 118–19). The teacher told us:

It was the summer term. There was a building site right in the middle of the catchment area, and we went there at the beginning, when they were digging out for foundations. The company were very helpful. They showed us round. I think they were concerned about safety, having this site in the middle of our catchment area ... they could use the school to teach children something about safety ...

The children drew at the site in their sketchbooks, and they met the workers there. Then we did investigations in the classroom. The sort of questions we asked were, What's the best material for a roof? They tried plastic, paper, fabric, metal, and they put chocolate and ice inside to see what would happen, to see what would melt first ...

They watched, and the language that came was important. They found that one thing would keep out the sun, and one thing that would keep out the rain – well, they were different things! They poured water on, and worked out what was fair test.

They looked at different materials, and discovered that plastic was good for downpipes and guttering, but not for windows.

The display surprised visitors. It was very striking, and aesthetically valuable because of its dramatic nature, because of the harmony and form ... When the children looked at the display, they saw all sorts of things. They explored different hardnesses, different softnesses, and they chose different graphic tools to record them with in their sketchbooks.

This is a classic case of a principle we outlined in the introduction: it is impossible to isolate a single subject in creative work of this kind. The work sprang, we were told, from a geographical topic on an area of town; was linked to a scientific project on materials; encouraged much language development, and was about art – as we can see from words like 'harmony' and 'form' used by the teacher.

We are struck, though, by the fact that harmony and form are not enough to stimulate an aesthetic response. Sometimes, art has to surprise us, to give us a jolt, to shake us out of our complacency. Nobody visiting this school during the period when this display dominated the entrance hall could fail to reflect on art, and technology.

The project was useful in yet another way. It is important that children should become more aware of the business life of the community. Here, we saw children and representatives of a caring local firm working together with remarkably creative results. There was a feature in the local evening paper about the project, under the headline:

Children Watch New Homes Take Shape

Hard hats at the ready! . . .

Barnes [the company] began the building work in January, and formed a close link with the school from the word go.

The first lesson the children were to receive was about safety on the building site.

The children's first visit to the site was last spring . . . Each was given a hard hat to wear, and the carpenters, brickies and roofers secured any loose items on the site . . . when the children visited, some of the homes were just being started, some were halfway through the building process, and some were almost finished.

. . . Barnes put up displays of bricks, wiring and plumbing items in the school's reception area . . .

'The spirit at work beneath the world of appearance' is a phrase from Irma Richter. She was referring, of course, to Leonardo da Vinci's interests in the natural world. This last project shows children learning about what lies beneath the surface of human-made constructions, like houses and public buildings, and also about the planning and negotiation that has to happen to make life in our complicated society work smoothly. It also shows them something of the spirit at work beneath the world of newspapers.

4 Art and mathematics

This piece of art is not a lie

child quoted by Mary Newland and Maurice Rubens
(1983)

Despite the fact that there is in mathematics an essential beauty, and that art is very much concerned with beauty, this has been a difficult chapter to write. Though this subject is concerned with order, understanding and proportion, less aesthetically challenging work happens in many schools than one might have expected.

The beauty of maths is largely sold short in our teaching, or recognised only in work on symmetry and pattern, often using printmaking techniques and collage. Perhaps we overemphasise number, where the aesthetic possibilities are indeed limited, and neglect area and geometry – issues that obsessed artists like Piet Mondrian.

When we discuss his pictures with children, such as 'Composition in Yellow and Blue', which is no more (or less) than clean, perfectly straight black lines bordering the two colours in immaculate rectangles, we cannot do so without using mathematical language. The same goes for the work of Kasimir Malevich and Theo van Doesburg (we have taken these examples from *The Pelican History of Art: Painting and Sculpture in Europe 1880–1940* by George Heard Hamilton). Our illustration (C14, page 120) shows a five-year-old using geometrical shapes in a similar way.

One teacher asked ten-year-old children engaged on a project on time to 'draw a second'. They had already looked at constructivist paintings like the ones discussed here. One result (see *Drawing to Learn*, (Sedgwick and Sedgwick 1993) page 113) is elegant, aesthetically interesting – and mathematics. Also, it is not difficult to imagine how Mondrian's work (see Heard Hamilton's book again) can lead to mathematics work on balance and area.

There is a project in Geoff Rowswell's excellent book *Teaching Art in Primary Schools* that has similar results to these, using circles rather than squares and rectangles. He suggests that children:

design a mobile based on circles within circles that will move round by themselves, suspended from cotton. Children should start by cutting out the largest possible circle from their piece of card. Other circles should then be cut from within this first circle . . .

He suggested that evaluation involves thought about art and mathematics: 'Was there a feeling of balance and unity to each of the mobiles?'

The school shown in these two pictures (C15 and 16, pages 120–1) demonstrates that it is possible to surround children with mathematics and art in the same displays. But regrettably, mathematics has largely grown to be, in many teachers' minds, a subject quite apart from the arts. Maths teachers, art teachers – both can be, at times, scornful of the other. One of us once sat in the staffroom of a high school, and the subject teachers had arranged themselves at significant distances from each other. Here was English, here was Science. And, it must be said, the biggest distance was between the art department and the maths department.

We suspect that this might be because mathematics is essentially orderly and therefore supportive of existing conditions, while the most exciting elements of art often threaten to subvert, because they are about learning in the dark.

Likewise the National Curriculum, by the nature of its structure, has tended to drive subjects apart. The notion of an 'integrated day' was common enough from the late 1960s to the late 1980s. As an example of a holistic curriculum, it summed something up: that we are learning about the world in Leonardo da Vinci's way. We make notes, we draw, we measure and, above all, we observe. But now this idea, contributory as it was to much exciting cross-curricular work in primary schools, sounds old-fashioned.

MATHEMATICS IS EVERYWHERE IN ART

Despite all this, Leonardo da Vinci made very clear the importance of mathematics to his work as an artist when he wrote in his *Notebooks*:

Let no man who is not a mathematician read the elements of my work.

There are many examples of art and mathematics which will find places in projects. Indeed, all art has mathematical implications. For example, when a young child looks at a sheet of paper with a view to making a drawing or a painting, she considers without realising it problems concerned with area. Constructing the picture requires reflection on symmetry and balance.

First, these nursery children made models using cylinders, boxes and other throwaway materials, and then sprayed the models with silver paint (see figure C17 on page 122 in the colour section). The mathematical experience included using the words for circles, cylinders, squares and rectangles. In art terms, they discovered new ways of applying paint, and produced a dramatically satisfying and *surprising* product. Once again, this was a language experience, as children 'participated as speakers and listeners' in a group as they worked.

In all nurseries, children construct with bricks, and it is worth remembering that this activity is both creative, in the problems it sets, and full of mathematics, leading to talk about height, weight, length and balance.

Figure 27 *Marbles painting* by boy aged four in paint

Figure 28 Taking a line for working with angles by boy aged eleven in felt tip pen and crayon

In the same nursery, children were given palettes of various colours and paper in flat trays with raised edges. They then dipped marbles in the colours and rolled them across the trays (figure 27). The language they used here was concerned with angles and lines.

In another design shown in figure 28, an older child has taken a line for a walk, using a sequence of 45, 30 and 95 degree angles. As he has been working, he has been learning not only about angles, but about parallel lines. This kind of work leads to the sort of optical art by artists like Bridget Riley.

THE CIRCLE

One beautiful example of mathematics was this project on circles at an infant school. The teacher described how the work arose:

> In the summer term the reception children were doing a general topic on growing as well as a maths topic on shape. As an initial stimulus which linked these two

topics, I showed the children a photograph of *Dandelion Circle* by the sculptor Andy Goldsworthy. The children responded to this in a variety of ways, such as finding different ways of making themselves into circles, individually, in groups and as a class, on the grassed area directly outside the classroom (figure 29). They collected natural objects and made circular collages in the

Figure 29
Making a circle

Figure 30
Circle with lines,
after Andy
Goldsworthy,
by boy aged five
in charcoal

environment. Then I showed the children another of Andy Goldsworthy's works, entitled *Interwoven Circle*. Jamie, whose first language is Japanese, chose to use charcoal in his interpretation of the photograph of the Goldsworthy piece. The resulting picture (figure 30) inspired other members of the class to experiment with charcoal as well.

Play can be considered as escape *into* oneself, fun is escape *from* oneself. This activity is play in that the children were reflecting on many mathematical concepts and their realisation in the environment, and we would suggest that play is also escape into knowledge around us, and not only a reflection of ourselves.

Any reader interested in Goldsworthy's work, and its both playful and serious relationship with mathematics, can find examples of it in Grizedale Forest Park, in the fells of Furness in the Southern Lake District, which contains marvellous examples of sculpture made from natural resources, wood, stone, flowers, etc, designed specifically to fit into this woodland setting. There is a catalogue with photographs of three of Goldsworthy's pieces, *The Grizedale Experience*, edited by Bill Grant and Paul Harris.

LOOKING AT SHAPES IN THE CLIMBING FRAME

A small unit in a topic on local geography began in the school hall, which, like most primary school halls, doubles as the gym. The teacher asked the six-and seven-year-olds to look carefully at the metal climbing frame. He pointed out the shapes in it – circles, squares, rectangles. In small groups, the children ran their hands round some of the shapes, and then talked about the experience to each other. As they did, they used the language of, among other subjects, mathematics:

> What is this? It is a smooth circle ... this is a square ... no it isn't, it is an oblong ... Look at this [a right angle] ... it's cold. It's the same shape as that window! ... Is this a right angle, too? ...

Figure 31

Figures 31 and 32
The climbing frame by
girls aged six in pencil

Figure 32

Then the teacher asked the children to draw the climbing frame – 'or any part of it, if you prefer . . . Keep thinking about the shapes you're drawing . . . Keep thinking about what they feel like . . .' (see figures 31 and 32).

The remark quoted at the beginning of this chapter – This piece of art is not a lie – expresses something of the tension of the kind of learning close observational drawing provokes. Most such drawing is of obviously beautiful things like teazels, flowers, trees and animals. Here the challenge was to draw something everyday and familiar, not commonly associated with beauty. The designs the children made on the paper are interesting. But when we try to identify the learning going on, the images become even more telling.

In this work the children are engaged in a three-handed struggle between what they see, their materials (inadequate as they are to convey these perceived realities) and their ability to record what they see. We should not view any of this – the poverty of a pencil's resources, or a supposed lack of ability on the part of a child 'to get it

right' – as necessarily a problem. We might, instead, reflect on what is passing through the child's mind as this struggle goes on. We would suggest that the tension we can see in their faces, eyes concentrating, tongues stuck in cheeks, reflects the intensity of their learning.

Later, a different group involved in the same project came out into the school grounds, and looked at the building. We notice again how the images are full of geometric shapes; and how the thick pencils, inadequate as they are, have helped the children convey something of the building's age and solidity (figures 33 and 34). In figure 35, another child has used pen and ink to draw a Welsh Nonconformist chapel. His drawing is full of rectangles, circles and triangles, and, as he draws, he is learning about the function of these shapes.

Figures 33 and 34
School buildings by girls aged seven in pencil

Figure 34

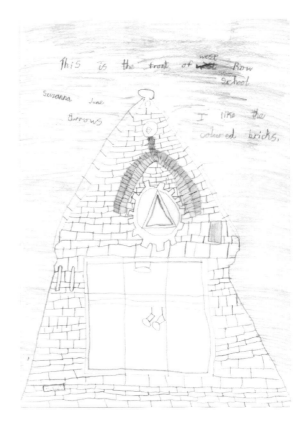

Figure 35 *Welsh Nonconformist Chapel* by boy aged nine in ink and wash

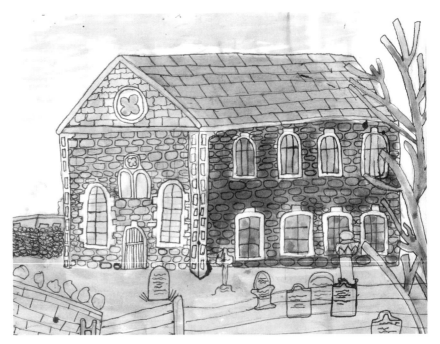

Although at this point the topic tipped over into being more about geography than mathematics, the children were constantly talking about the shapes they saw. They became more aware of shapes in their environment. We noticed how they also searched for shapes in machines: one girl commented on the triangle the car bonnet makes when it is raised. They also found shapes in their own designs and models.

Some aspects of the relationship between mathematics and art that we have not illustrated include:

- constructing using only linear items, for example, straws
- children can see mathematics in the work of many artists and designers ubiquitous in collections of reproductions. Examples are M C Escher and Bridget Riley and architect's drawings. Such work leads to discussion of angles, length and pattern. Escher's work uses a wide variety of mathematical concepts – spatial structures, reflection, symmetry, multiplication and infinity
- angles in building
- tessellation, which is evident in much Arabic and Roman patterns

John Lancaster, in *Art in the Primary School*, has helpful examples on topics which include mathematics. Water, for example, involves study of:

Measuring (liquid containers); volume (also displacement); size (playground, puddles, sinks, ponds, lakes, seas; rivers etc); depth . . .

In our section on machines in Chapter 3, mathematical implications about gears and ratios, mechanics, power sources and conversions are obvious. As the children drew the car, they were playing with mathematical concepts such as angles and length.

In one school, children had drawn faces, cars and lorries on squared paper, using straight lines and co-ordinates. They were then

told to multiply the co-ordinates by various numbers, producing some images that were simply twice or four times the size of the originals, and others in which the vertical co-ordinates were doubled, and the horizontal ones halved – thus producing distorted images. The example shown in figure 36 is a simple one of a ship. The children then made very large images based on multiplying the same co-ordinates. Because some of them did this in groups, the language and planning was purposeful. However, in some of these cases, the images became too complicated to reproduce here.

Figure 36 *Ship* by girl aged eleven in felt tip and ballpoint pens

I did my first ship using the co-ordinates 2,1; 6,1; 1,2; 3,2; 5,2;7,2; 3,3; 5,3; 2,4; 3½,4; 4½,4. And then I doubled them. I am going to double them again and put it on bigger paper
Chloe

Most of the art/maths relationship is implicit in the rest of this book. Also, in this series, Kevin Mathieson's *Children's Art and the Computer*, Margaret Jackson's *Creative Display and the Environment* and our own *Drawing to Learn* all include much work showing the relationship between art and mathematics, particularly with regard to shape, area and line.

We end with the voices of children. These two five-year-olds are talking about a tesselation exercise (see figure C14, page 120):

We had to put big squares down, then middle-sized squares, then a little one down . . . all on top of each

other … We hadn't to get glue on them. [Oh yes we did, on the back, to stick 'em down!] Yeah, but not on the front, or we'd make it look messy [No, not on the front]. We had to put one square up to the next one, mustn't show the white … there's mustn't be any white showing [The orange had to be right up against the black] Yeah, the orange had to be right up against the black.

Here, once again, is the integrated curriculum: the way children experience the world: art, mathematics, English all together, and their relationships with each other. And also, the children's relationships, tingling along the nerves ends of everything we do in our schools. Who are we to break it up into little testable bits?

We finish with figure 37, a symmetrical collage, and a flower pattern (See C18 on page 123).

Figure 37
Symmetrical collage by boy aged five, paper

5 Art and the humanities

> Art has one vital function, above all others as far as society is concerned. Every work of art, whether it is simple or complicated, old or new, loveable or controversial, in whatever medium – dance, painting, poetry, music, drama – every work of art, I say, reminds our elders and betters – politicians, teachers, inspectors, managers – that we, as artists, are not mere figures on a checklist, but human beings with human duties and human rights. And it reminds them as well that everyone else is a human being . . .
>
> Emily Roeves

The Humanities are, in the first place, about people, whether children or adults. And all of us are concerned with human beings by our own nature. The humanities are about life and living and, as the quotation above suggests, they are linked to art unbreakably, because art expresses our humanity, indeed asserts it and insists on it, both to ourselves and to those who would dragoon us into automatons (in Louis MacNeice's famous words). By implicitly (and occasionally explicitly) insisting on our humanity, the arts and the humanities place themselves at the very centre of any humane curriculum.

One attractive aspect of the humanities, educationally speaking, is that they are by their nature controversial. History, geography, religion: we all disagree with each other about all of the subjects raised by these words. Where do you stand on the royal family? On the partition in Ireland? On the role of the church in decision-making? On the use of third world produce? Essentially the humanities are, like life itself, about politics.

Of course, this can spell trouble. By teaching controversial subjects we inspire controversy, or we are not doing our work properly. Indeed, it is possible to argue that all true education is inherently controversial, because it is about issues that concern all human beings. And all human beings have varying status and position, and different

angles on the world. We all have vested interests, and we all have unsatisfied needs and claims on resources. Education, we might argue, like the humanities, and like the arts, is inherently political.

Perhaps we as teachers should be aware of, above all else, the need for sensitive and creative listening to children, meanwhile taking nothing for granted about what they are thinking and feeling, in relation to whatever subject matter we are introducing. And while we wonder what their beliefs and prejudices are, it would be no bad thing to ask ourselves what ours are as well.

The history of the Vikings may not demonstrate this controversy – but as soon as we look at more recent history, we can see how disagreements arise.

Geography, as well as history, is rooted in controversy, because it is concerned with the world's resources and our distribution of them; with boundaries and borders; with politics. Theories advanced by scholars are, far more often than we automatically think informed by opinions rather than facts; by a political, religious or ideological stance.

Art then has this important link with social studies: it, too, is often controversial. We need only to listen to viewers at an exhibition. One such was composed of work based on the seaside village of Walberswick in Suffolk. It moved from orderly representations of the sea and the dunes, and the marshes behind the dunes, to large, garish abstracts made of painted wood. One man said 'I like to know what a painting's about, those new, these *modern* ones, they *irritate* me. Another man promptly interrupted: 'Well, I like those abstracts *because* they irritate you . . .'

Another social aspect of the art at this exhibition lay in the fact that many of the pieces showed us social conditions: fishermen, children playing on the beach, landowners presiding over their property. Some of the older pictures enabled us to reflect on geographical changes in the area: changes, for example, in land use. Some pictures that don't, at first glance, appear controversial, are. Take *Mr and Mrs Andrews* by Thomas Gainsborough. One viewer looks at this picture and sees a rural idyll, England in all its confidence in the middle of the eighteenth century; the young squire in charge and all's well with the world. But another viewer may notice the cross expression on Mrs Andrews' face, her primly held hands and

feet, and her husband's awkward arrogance. Is the artist making fun of his subjects? And where are the agricultural workers – out of sight and mind of the artist and the viewer?

AN UNCONTROVERSIAL EXAMPLE FROM PREHISTORY

These children have been studying the formation of the world, and in the colour section we show some of the pictures they painted to illustrate the various stages of formation. On the back of these pictures (C23—C28, pages 126–8) the children (all ten years old) have written:

1 Fifty thousand million years ago there was a huge explosion called the big bang.
2 Giant volcanoes erupted. Little stones and rock dust were thrown into the air.
3 There were rainstorms for thousands of years.
4 The seas were much warmer than they are today.
5 400 million years ago crabs and fish and [illegible] started to fight and eat each other.
6 The fish developed lungs to breathe air and some fish started to develop legs.

Later, we showed these paintings to other children, and asked them to imagine what it was like as these things went on. One of them, responding to point 2, wrote:

Hot tarry air, rippling with energy. A crowded feeling of low clouds. Ecstatic lightening jumps for the sky. Thick unsettled dust rising. A prickly burning of lava and molten rock. A wonderful sun at the world's birth.

Three things happened then. Note how, in the course of these events, the distinction between Humanities, Art and English becomes creatively blurred.

First, the teacher asked this writer whether he needed all those 'ing' words. Such words (present participles), he suggested, tend to

weaken writing, while main verbs give it muscle, making things happen. Second, he recommended the writer put obliques (/) where he felt a new line might begin.

And last, he corrected the spelling. Then the writer wrote his second draft:

The Beginning

Hot tarry air ripples with energy.
A crowded feeling of low clouds.
Ecstatic lightning jumps for the sky.
Thick unsettled dust rises.
A prickly burn of lava and molten rock.
A wonderful sunset
at the world's birth.

HISTORY

Sometimes, historical topics have been graveyards for art eduction. This is when, as Duncan Allen put it in *The Expressive Arts* (Sedgwick 1993), 'art is used as a merely decorative aid for history teaching'. When we saw this Viking project going on among six-year-olds, we were struck by a freshness and vigour that seemed to us unusual. It compared well with those stereotypical, static images of Viking ships we are used to.

To a large extent, the vigour was achieved through the variety of materials available. The children used paint, torn and cut paper, glitter, milk bottle tops (the shields), cotton wool, string, pipe cleaners, wool, silver paper, felt, and synthetic fabrics. The availability of all these things meant that they constantly had to make choices, and choice, requiring as it does intellectual activity, is of itself educational. Thus, other things being equal, the less choice we give children in an art lesson, the less educational is our teaching. (See C29—C31, pages 129–31.) The greater the number of opportunities they have to make decisions, some of them difficult, some easy, some as individuals, some in groups, the greater the educational possibilities.

The teacher pointed out to us that this activity was more than art and history:

> It's maths ... there's considerations of size and dimensions ... There's research in books to find out about ships, Viking clothes ... And there's language – the two boys who did the sheep's wool picture are not particularly articulate, but throughout their work on this piece they were talking constantly, and talking to some valuable planning purpose ...

The teacher told me that, as well as the wide range of materials this quality of work requires, there was also much discussion, some with the teacher present, some without her.

> What materials might we use for the Viking ship?
> How can we make the sea look rough? The warriors look stern and dangerous?

There is no hint of template about any of this work. Children do not learn effectively when trapped inside an adult image inspired by photographic correctness (which is, after all, only *one* kind of correctness). They learn by working out their own image, often collaboratively, as with the sheep's wool picture.

MOCK MUSEUM DISPLAYS

One school runs a 'mock museum' every year. We quote from a leaflet issued to teachers of year 5 pupils in 1994:

> The mock museum has been set up in order that all pupils will have the opportunity to improve skills of observing, selecting and recording information prior to our visit to the British Museum where they will be expected to use these skills. It is hoped that sufficient information can be recorded from the first-hand evidence of Egyptian artefacts we used in a six-week printing project.

Before the visit to the British Museum, the children were presented with the following tasks:

- Observe the artefacts on display and distinguish between first-hand evidence and other items.
- Choose an item which particularly interests you . . .
- Select from that item a section of pattern which is capable of being repeated . . .
- Record what the section looks like by isolating the elements of LINE, TONE, SHAPE, COLOUR, TEXTURE . . .
- Make an image based on your selection and recording.

It is striking here how often words to do with choice come up. This is a clear example of children being given autonomy over their materials and their subject. And, as we have quoted elsewhere, Robin Tanner makes it clear that choice is itself educational.

Our example from this project could have fitted as well in our chapter on mathematics. The child had used an Egyptian motif and made a printed pattern (C32, page 132). The children visiting the British Museum had a worksheet:

> Have a good look around these two rooms. Look very carefully at the decoration on and in the mummy cases and coffins . . . Choose one thing which interests you and which is appropriate for the task you are being asked to do . . . Select from that item a section of the design which is capable of being repeated . . . record the section you have chosen very carefully . . . You should do two drawings: one should be line using pencil, one should be in colour using chalk pastel, wax pastel, or coloured pencil . . .

PORTRAITURE

One area where the humanities are mutually supportive is in the area of portraits. Look at Chapter 2, where children have spoken with enormous vigour and sensitivity about the Freda Downie portrait

Girl in a Straw Hat (see figure C2 in the colour section). Other pictures from the twentieth-century British tradition of portraiture alone that evoke similarly creative responses from children include the following:

- *W Somerset Maugham* by Graham Sutherland
- *A E Housman* by Francis Dodd
- *T E Lawrence* by Augustus John

All these are in *Master Drawings from the National Portrait Gallery* (Rogers 1993). These are real people, who laugh and cry like us. What can we know of them from these pictures? Of their characters, the way they move and dress, speak, react?

Here are some questions we might ask children while they are looking at these reproductions:

- Look at the lines on this man's face. What do they remind you of?
- Do you think the artist liked this person? If so, why? If not, why not?
- What is in this sitter's mind/heart at the moment?

Here is a poem written in response to the Sutherland portrait of Maugham:

> William, your face is dark and long.
> All the lines
> Show in your anger.
> Your old twisted mouth is tight-lipped.
> Lines on your scalp show through
> Your thin hair.

We add another dimension to this work when children look at portraits from different cultures.

THE SEA

In C33 (page 133) we have evidence of children:

- looking at the sea
- reading about it
- hearing music (Fingals Cave, La Mer, for example)
- visiting it (first-hand experience can never be bettered in any learning)
- talking about it

RELIGIOUS EDUCATION

Glory be to God for dappled things –
For skies of couple-colour as a brinded cow;
For rose-moles all in stipple upon trout that swim …

Gerard Manley Hopkins' famous poem 'Pied Beauty' demonstrates the connection between one aspect of religious experience – worship and praise – and art. Indeed, as children carefully draw the creatures in the science chapter, they are reflecting on nature and its creation, and, therefore, arguably at least, on God the Maker.

Children are creators like God in Genesis and the other creation myths. Our work in art has the same function as creation and Dylan Thomas's poetry, which he wrote for the love of Man and in praise of God.

The Poet's Christmas story

We asked some children to look carefully at pictures of the first Christmas. (These were old masters gleaned from the previous year's Christmas cards.)

- What can you see in the stable?
- What would the straw feel like? The shepherd's clothes? The animals' breath?
- What noises would you hear? What smells would you smell?

We then asked the children to pretend to be someone else looking at the scene. An example will make everything clear:

A Cook looks at the stable

He sees the straw on the floor like
spaghetti on a plate, without bolognese.
The smell of the stable
reminds him of mustard.
Jesus is crying as though he wants some more warm milk.
Mary smells as sweet as the sugar we put in the tea.
The shepherds' gifts
look like big fruit cakes.
Joseph smells
like a warm mince pie being eaten on
Christmas Day.

Another boy was a poet:

A bristled bed
and lots of heads
all watching the baby boy.
The dusty floors
and big fat boars
all watching the baby boy.
Mary and Joseph
and all the people
all watching the baby boy.
The cows and oxen
donkeys and ewes
all watching the baby boy.
The starry night
dark then light
shining on the baby boy.

Figure 38 *Daddy is giving me a cuddle*
by girl aged seven in crayon

Figure 39 *Mother and child*, after Picasso, by boy aged four in charcoal

Figure 40 *Parents and child* by boy aged four in crayon and charcoal

Christmas suggests we might look at families, as these nursery children did.

We can use many patterns from religions, such as rangoli patterns used by Hindus at Diwali; and mendhi, henna designs usually painted by women on the hands of Muslims and Hindus at festival times like Eid (Muslim), Diwali (Hindu) and for weddings. They are useful here in helping children understand different cultures.

Other study of the art of religions reveals the fact that, for example, Islamic art doesn't reproduce the human form at all. These pictures are from a different tradition.

SOME WORDS ABOUT PHYSICAL EDUCATION

This subject lends itself to art concerned with movement. Years ago one of us took a class of five-year-olds into the hall for a physical education lesson. It was the beginning of the school year, and the children needed, it seemed, some basic practice in running.

So they ran, as children always do, round the hall, like water going down a plughole. I said (Fred) as many infants teachers have, before and since:

> Can I see you running in different directions?
> Can I hear you running very, very quietly?
> Can I see you running without touching each other, and
> changing direction every time I clap my hands (of course,
> you'll have to be very quiet to hear me clap my hands)

It is always remarkable, of course, how the quality of the children's movement improves after questions like these.

Later I asked the children to stop in their running when I clapped my hands, and make a stretched shape that had two points of balance. Had the children been older, I might have asked them to make shapes balanced on two points of their body: knee and elbow, perhaps, or thigh and forehead.

In a dance lesson, I might have asked the children to hold a position when they were expressing violence, or affection; anger or friendship; growth or decline; birth or death.

Now, I ask them, draw yourselves in those positions (this even before they had got fully dressed after the movement/physical education lesson):

> What did you feel like? Your legs, your arms?
> What did the other children look like?
> Can you show in your drawings how your body felt?

For some other examples of work like this, see Chapter 3.

SOME WORDS ABOUT MUSIC

Music is, notoriously, the most difficult art to write about. It is its own expression. It doesn't necessarily refer to anything. It evades words about itself. It can, and, indeed, usually does, exist without the

partnership of words: those of us who love song (with its lyrics) often forget we are in the minority of music lovers.

The National Curriculum says that children should 'respond to musical elements, character and mood of a piece of music, by means of movement, dance or other forms of expression'. This is a sound and traditional way of coping with the challenges that music presents.

Children can, of course, also respond to music with visual images. Perhaps this is the ideal way of responding to music, unless we count responding with more music.

These six-year-olds were in a school that had recently acquired some new musical instruments, and they began to get to know them, not only by playing with them, but also by drawing them. First they drew in the way that is most familiar to children, concentrating on the line the graphic tool (in this case a pencil) makes. Then they drew the same instruments again, concentrating on shading (see figures 41 and 42). Once again, this points out the different kinds of line that we can make. Stacey, who drew figure 43 told me:

The instrument is a kind of shaker. It makes a shaker noise. My drawing is all shading. We had to do the instruments shading across.

Figures 41, 42 and 43
Shakers by six-year-old
group in pencil

Figure 41

Figure 42

Figure 43

Music led all these children to think. Now thought is underrated in our education system today because it isn't observable. You can't construct a behavioural objective for thought, anymore than you can construct one for prayer. This had led us to praise the observable over the thought or imagined.

One teacher wrote to us about a five-year-old's painting *After the Blue Danube* (C34, page 134):

She is a rather disruptive child . . . She wears glasses and for the last term she has had to wear a patch over one eye. Two weeks ago she had the patch removed and now wears glasses permanently. I asked her to paint a picture to express her feelings of how she felt, while wearing headphones and listening to 'The Blue Danube'. She put on the headphones, removed her glasses, something which I have not seen her do, sat for a few moments, and then started to move her head to the music. She picked up a paintbrush and began to paint a pattern . . . She was totally enthralled in what she was doing, using brush movements I had never seen before. I praised her for her lovely painting. She has since behaved differently, working well and quietly . . .

That, to us, is a moving testimony to the power of the arts in general, and to music in particular. Through the teacher's language we can see something calming happening.

A five-year-old listening to the 'Aquarium' section of Saint-Saëns' *Carnival of the Animals* was, no doubt, also calmed, as her brushstrokes matched themselves with the drifting chords and notes of the music.

The children in this class told me that they had listened to lots of music. They'd done a project on sound, and had heard aboriginal music, and made didgeridoos; they'd heard African drums. All this helps them learn about the sameness that unites, and the difference that excites, all members of the human, art-making race.

Figure 44
African shaker by girl
aged five in charcoal

Figure 44 is a shaker from Africa, and C35 (page 135) is a painting made by a five-year-old while listening to drum music from Malawi. All this work is evidence of children coming to terms with their place in a wide, varied world.

6 Art and Personal, Social and Moral Education

It is the business of education to make us freer and more creative

Lawrence Stenhouse
An Introduction to Curriculum Research and Development

I cried and cried
And cried and cried.
I buried him in our back garden,
Laid a gravestone and a flower.

child's poem

Personal, Social and Moral Education (PSME) involves qualities and attitudes, as opposed to skills and facts; understanding as opposed to rote learning. It insists that the learner is actively constructing his or her own world as s/he goes along, rather than merely being filled with the inherited knowledge of previous ages. It acknowledges that right and wrong are difficult and shifting ideas, not simple matters.

It is concerned with what we do in the classroom to help children understand themselves and their responsibilities and duties to each other. How they cope, in other words, with their intricate, loving, sometimes hating, sometimes indifferent relationships.

A central thread in Personal, Social and Moral Education is how we can teach each other to face realities about life and love and death; about race; about violence. It is, as John White (1990) puts it, 'a concern for other's flourishing . . . as premised on a self-determined life . . .'

Arguably, Personal, Social and Moral Education constitutes the whole curriculum. Every mathematical, scientific and technological project, every painting, every dance, every piece of writing, every musical performance, is a research project into the relationship between the individual and the rest of the world. As we work in art, we ask of ourselves a profoundly educational question: Where do I stand in this 'dark world and wide'? How can – how *should* – I relate

to the things, some natural, some of those human; some artificial, around me? And the people? What is a self-determined life? How can I, at the very least, avoid impeding other's flourishing?

Personal, Social and Moral Education is far more than the curriculum of moral panics described in books than concentrate on health education. Such a curriculum (PSHE not PSME, 'Health' instead of 'Moral') is concerned with our control of children's behaviour, while Personal, Social and Moral Education is concerned with children gaining control over their own lives.

Teachers of Personal, Social and Moral Education are concerned with openness and justice; using art (words, movement, brushstrokes, lines, forms, musical notes, speech) to make their and their children's position clear, and in increasing children's understanding of themselves and their relationship with the rest of the world.

Teachers in this area are concerned, through education, to make the children they teach better teachers and parents of the next generation, so that they will educate their children to be healthier people.

It is possible to draw out some specific threads. Our emotions, for example. We could have drawn our main example from any of the emotions, and from any of the human predicaments children see on the television: peace, war, work, love, hate. Our example is anger.

DEALING WITH ANGER THROUGH DRAWING

As teachers, we have an important role in encouraging children to come to terms with relationships, and in particular with emotions, by means of art. Joy, happiness, worry, anger and fear are all important aspects of life to which we can profitably help children to respond. We are choosing anger as an example of one way of working, and the medium we have chosen is pencil drawing.

You can't, of course, truly deal with anger by simply drawing, or writing, about it. You probably have to shout, scream or sulk. But every artistic attempt to understand our feelings is a step on the road to understanding.

When seven-year-old children were asked to 'draw what it felt to be angry', it was a personal, social and moral education lesson as well as an art one. It was also a language lesson, of course, because the planning was such that the children could not but talk.

The teacher put some questions:

- What sort of lines look angry?
- What sort of lines *feel* angry when you draw them?
- Can you make your pencil make angry shapes?
- Can you make a picture to show how you feel inside when you are angry?

It may well be that we, as adults, don't understand the point of (and the answers to) some of these questions. But that is because of our ignorance. Children, closer as they are to the frank expression of the need for basic things – food, drink, warmth and love – understand these questions readily enough.

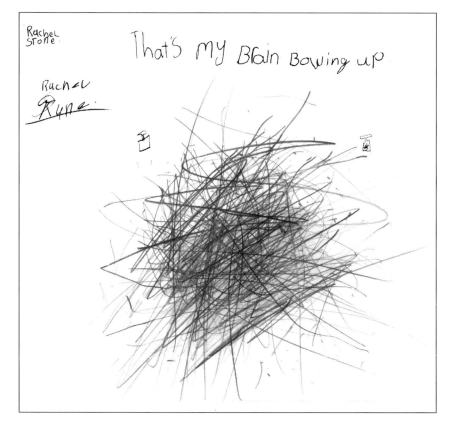

Figure 45 *That's my brain blowing up* by girl aged seven in pencil

Rachel added to her drawing (figure 45) the words 'That's my brain blowing up', adding two of the sort of little detonators that you see in films, if nowhere else; and Lee told us that he had used 'three kinds of pencil, a normal one, this one [the sort of pencil that irritates most teachers, including us, over a foot long and embellished with a tassel] and a sketching pencil' (figure 46). One line comes in from the top left corner, like a fuse. Then the drawing explodes from a still, suddenly ignited centre, like a rage.

Figure 46 *Anger* by boy aged seven in pencil

Jacob had been reluctant to write during the previous hour, and had used this drawing to express himself (figure 47). He had looked sorrowfully at me everytime I came to see how his poem was coming along. In his marvellous drawing, a face judders with electrical lines, as if, here, now at last, he has been allowed to express the frustration he'd been feeling all afternoon.

All this speaks to us yet again about the importance of choice. Sometimes children need to use graphic tools that we as teachers don't particularly like – in this case, an outsize novelty pencil. Other examples (we have noted elsewhere) are felt tips and ballpoints. Rachel and Jacob have used the opportunity of choice between words and images in different ways.

Figure 47 *Anger* by boy
aged seven in pencil

Another teacher initiated a similar experiment with a group of ten-year-olds. He asked the children to look at abstract drawings by various artists, and to collect words that would adequately describe the kinds of lines the artists had used. One child walked around the room collecting words:

zizzy, square, circular, bent, hard, soft, small, parallel, squiggly, large, huge, vertical, big, triangular, blobby, smudgy, scribbly, curved, sharp, angular, thin, cut, curly, diagonal, jagged, right-angled, light, flicked . . .

The teacher asked them what they thought of the drawings (Moshe Kupferman's *Drawing 1971* and Christopher Le Brun's *Idea from Pillar*). Did they like them? What are they like? How did they feel about them? Much as the children were more open to questions about the quality of lines, they were more ready to look at these pictures without an immediate negative response:

They're weird, they're funny things, different from normal pictures . . . They're a drawing, a drawing of something, but you can't see it. They're complicated.

I don't like them, 'cos they're, the way they blend in is silly.

I like them, the way you have to find what's in it . . . I like the patterns, the shades . . .

Figure 48 *Anger* by girl aged ten in pencil

And then the teacher set the children the same task: draw anger (figures 48 and 49). Use the method of the artists whose work you've been looking at. Use the techniques you can see in their work. The children said, as they drew:

It's hard to draw, to make 'em look impossible . . . I like doing it because you can just scribble around. It puts your mind at rest . . . [another child, responding to that] It makes *my* mind go all dizzy!

The drawings are far cooler, far more controlled than the anger drawings by the younger children. One of the comments – about one child's mind going 'all dizzy' – contradicts the previous one, and demonstrates again the variety of responses art brings about, and the

intensity of our engagement with it if we take it seriously. 'Children who learn to look', write Mary Newland and Maurice Rubens (1983):

> learn to question, to discover, and to understand . . .
> Looking through drawing prolongs the looking . . .
> Looking encourages concentration . . . Looking absorbs, engages, calms and sensitises the learner . . .

Figure 49 *Anger* by boy aged ten in pencil

Of course this is true when children look at and draw natural objects, or parts of car engines. There is plenty of evidence for this in all the books in this series. But it is also true when, as here, they examine, and draw, their feelings.

Some nursery children (their drawings are not illustrated here) have been talking about what makes them angry. One of them, Tracey, had arrived at school cross about something – possibly the bad behaviour of the cat – and the conversation had developed from there. We asked them:

- What makes you angry?
- What do you look like when you are angry?
- What do you feel like doing when you are angry?
- What do you sound like when you are angry?

They listened to a poem 'When I was angry', by Fred Sedgwick (Sedgwick 1994):

When I was angry
I screamed at my mummy.

I was quiet
for a long long time.

I curled up
in her arms

and said 'Sorry'
and she said

'That's all right
My Little Chickadee'

and then she tickled me.

The children were also familiar with a classic children's story about anger and revenge – Maurice Sendak's *Where the Wild Things Are* (1970). Like 'When I was angry', this text also ends with a resolving of the problem, a warm supper; this happy ending seems to be important in talk about these emotions (though David McKee's excellent *Not Now Bernard* (McKee, 1980) doesn't make things all right).

In order to get these resolving words, these little sacraments of peace-making that families have, we ask children: 'What does Mummy/Daddy/Uncle/Auntie call you when you've made up ? When you're friends again?' This leads to some delightful conversation, and sweetens the atmosphere after all the talk of anger:

My little kipper
My sausage
My little baby
My darling ducky
My chuck
My flower
Angel-cake
Darling Deek

The above are all actual examples. Work like this has several functions. One is to enable the children to communicate, to each other and to the adults in the classroom, how they feel or felt. This communication is, just as importantly, to themselves: as they draw they are learning about their feelings. Being given a chance to reflect on their emotions is healthy personal, social and moral education.

Also, the children's drawings help them to (as Wordsworth put it) 'escape from emotion'. Schools, like art, have an important function in this respect. Conventionally art is seen as a romantic grappling with the emotion as it holds us. On the contrary, most artists work as a relief from the extremes of the emotion. Art is often (Wordsworth again) 'emotion recollected in tranquillity'.

But as well as language, there is a powerful art presence in this work. It teaches children that art is about everyday life, about our moments of joy or (as in this case) anger. It teaches them that the techniques they are learning are relevant to the lives they lead at home.

We say to the children:

- Make your mouth angry.
- Make your teeth and your eyes angry.
- How do your hands look when they are angry?
- What about your feet and your knees?
- Look at each other being angry.

Often we make them act anger. The results are expressive mouths and eyes.

We have used anger here as an example, but the same questions and teaching techniques apply just as well to other emotions, such as happiness, joy, worry and fear. Discussion, drawings and pieces of writing like these form a useful part of that ubiquitous September topic 'Ourselves'. This work is valuable to the children for several reasons:

- It helps them understand their emotions.
- It helps them understand other people's emotions; helps them to acquire the *language* of emotions. It is far better to be able to say 'You are making me angry/irritated/annoyed' than to have to hit out because you haven't got the words to express your feelings.
- It helps them build up technical drawing skills.

DEATH AND BEREAVEMENT

The other aspect of education for which we have examples is death. Extreme? But everyday.

Art helps children to come to terms with death. We have two broad options: we can open the issue for discussion, or we can hide it away. In practical terms, when the class hamster dies, we can tell the children, talk about it, bury it, remember it in poems and stories, draw it; or, we can, before the children discover the death, get rid of the old hamster and buy a new similarly marked and coloured one and pop it furtively into the old cage.

Here is an example of a school enabling an open approach to death. It is in the form of a poem (figure 50) and an accompanying drawing (figure 51). But Hamlet the hamster could have been celebrated just as effectively with a painting, or even a piece of music, or a dance.

Figure 50 *My Hamster*,
poem by girl aged eleven

My Hamster

He was a golden brown,
He had tiny pink triangle ears,
And great, big rubber cheeks
Which, usually were streached out to full,

He used to scamper about his cage busily,
Like he was laft late for some important meeting,
But wasn't sure where,
On his wee pink feet.

He loved to nibble nuts,
And Sunflower seeds,
He liked my fingers stroking him,
But, then he died.

I cried and cried
and cried and cried
I buried him in our back garden,
Laid a gravestone and a flower.

Figure 51 *Hamlet*,
died 16 February 1994,
by girl aged eleven

ART AND MULTICULTURAL EDUCATION

Art has a powerful function in helping children to understand that the human race is varied in its cultures and religions. The children in this nursery frequently see powerful images from other countries, like the black doll (C36, page 136) and this African head (C38, page 138). They have seen many Asian artefacts, and they are surrounded by words in many languages other than English. They have made these drawings (figures 52, 53 and C37, page 137).

Figure 52

For work of this quality, children need opportunities to feel as well as look at their subjects. These children had held the doll and the head, running their hands along the wood, feeling it and commenting on it to each other.

They also need purposeful questioning from the teacher, of the kind we have quoted throughout this book, about texture, emotion, and various details, like the eyes and hair.

They also need instruction: not in how to use a crayon or pencil, but in looking, in paying attention. We can see clearly how, once the details of the different delicate patterns have been pointed out to them, they record these patterns with a painstaking, concentrated, loving attention (figures 52 and 53). Somehow, in the drawings of the

African carving, (figure 53, the larger of these two pieces, is over 60 cm long) we can feel the weight of the original things, and we can see that it has become an important component in the children's life for the time they were so intently studying it.

Figures 52 and 53
African carvings by boy and girl aged four

7 For art's sake

> ... truly painting is a science, the true-born child of nature ...
>
> Leonardo da Vincl

This book is about the way in which art helps us to learn about ourselves and the world we live in. In other words, it is about art *as a teacher*, not only of children, but also of teachers.

Miroslav Holub, a poet who is also a leading scientist, uses his art 'as a slide in an experiment: as a transparent medium ... [he] brings to poetry the habits and mind of a scientist' (Holub, 1984). His art is like a piece of basic scientific apparatus through which he learns about the world. We, as teachers, can bring to science (or the humanities, or mathematics, or English, or physical education) the way the arts teach.

In this chapter we explore the way in which art itself is an agent, in a sense without the benefit of the other subjects, of learning. There are characteristics of art which make it unique; that do not appear in other aspects of education. They are the qualities of the elements of art, non- and pre-verbal: line, colour, form, space and tone. This language is parallel to the language of music, and both are powerful modes of thinking, acting, and, of course, communicating.

We see art as a purposeful figure, sleeves rolled up, glint in the eye, with a passionate intellectual and emotional interest in what artistic activity can teach us all, whether we are children or adults.

After all, as Leonardo da Vinci wrote in his *Notebooks*

> The painter [artist] is lord of all types of people and of all things. If the painter wishes to see things that charm him it lies in his power to create them ... In fact whatever exists in the universe, in essence, in appearance, in the imagination, the painter has first in his mind and then in his hand ... Truly painting is a science, the true-born child of nature, for painting is born of nature ...

There has been a different emphasis on art in the last hundred years. It has been seen as an agent of 'self-expression'. But the emphasis merely on self, and self-expression rather than on learning, can be unhealthy and a bad influence. Through art we find meaning in the world *outside*, as well as inside, ourselves. In art, as in play, we escape into meanings concerned with both ourselves and everything – human, natural, artificial – that surrounds us.

The same is potentially and potently true for all the children we have taught. Lawrence Stenhouse saw teaching as an artistic activity. We are reversing that, and suggesting that art is a teaching activity. That is also true: as far as teaching is an art, art is a teacher.

But there is a problem. Can any way of thinking and working exist isolated from other ways of looking, other ways of understanding what it is to be a human being in a society? Of course it can't. And in all the work in this chapter, however art-oriented it is, we can see other learning. As you draw or paint, you inevitably think. And as you think you often (always, some might say) use language.

As you look at a blank piece of paper with a view to making a design, you inevitably reflect on spatial matters, and thus on geography and geometry. When you use a printing machine of some kind, you think about its technology.

To say, then, that we can think about art entirely in isolation from everything else would be absurd. It would, in a way, deny our humanity, as thinkers, talkers, measurers, actors, makers, listeners, technologists and scientists.

There are many examples in this book of children responding directly to their view of the human predicament. Look for example, at the picture of the mother with her baby, where the artist seems to be anticipating actively through the medium of paint on her probable future as a mother; look, again, at the children responding to their own anger in Chapter 6; and, in the same chapter, children studying the artefacts of other cultures. All these show the power of art to help us understand. Art is a good-natured, firm teacher, constantly challenging us all, adults and children, first, to want to know more, and second, to use our intellectual energy to push the boundaries of our understanding forward.

CHILDREN USING ART TO MAKE ART

These children who look constantly at art from ethnic minorities, reflect on a vital – possibly the most vital – cross-curricular theme, multicultural education. Their teacher and nursery nurse always have books of reproductions around. They'd prefer originals, of course, but that's only occasionally possible. In particular, the children often look at non-European art. Frequently they arrive in their classroom to find an Indonesian statuette, or a Dominican costume, borrowed from the local educational authority's multicultural resource centre, or from the teacher's private collection, or from a neighbour. This familiarity with what the human race in all its forms can do is important if we are serious about multicultural education.

Recently, the children in this nursery had been looking at a Dominican head, 'a souvenir', the teacher tells us, 'made of some sort of seedpod'. She went on:

I just sat at the table with them, and they came over to feel it and so on ... I didn't say, 'Today children we are going to do a drawing'. I just sat there with the head and they came over. I asked them, 'What do you think it is?'

None of them thought it was scary, like my twelve-year-old son did. He didn't want it in the house!

There was a discussion about it – the texture, the weight, the colours, the sounds of it. It has a kernel inside that rattles, and one of the children thought it was an egg, and he wanted to open it ... I had made the suggestion that we were going to use oil pastels, and then I asked them to look at the oil pastels and the head, and choose the colours that they would need ... so they chose the colours.

Luke did his very quickly, in about a minute, I should say (See C41 on page 141). His mother collects all his drawings, and when I took this display down, he said,

'Where is my drawing?' He will have to have it back when you have finished with it. I like the way he has put his name on it. He is saying 'I am here!'

One thing that bothers me – people keep saying, they're not by nursery children, surely? There are two implications I don't like. One is that they're too 'right', too accurate to be by nursery kids, as though photographic accuracy is what we're after. And the other is that these people don't expect work this good from young children.

One colleague said, 'How come they can draw like this in the nursery, but when they come into school they can't draw?' as though I was doing the drawings myself! I also noted what I thought was an offensive distinction drawn between 'nursery' and 'school' . . .

Listen to this teacher again:

I just sat at the table with them, and they came over to feel it and so on . . . a discussion about it – the texture, the weight, the colours, the sounds of it'.

These words sound more appropriate to a PhD seminar than to a nursery school, and suggest that children are more than capable than we sometimes suppose of dealing with making their own decisions about what they are going to do.

A central question here (as in all education) is: What do we *expect* children to do? To take two extremes, if we expect them to be entranced by stale cartoon images from old Walt Disney films, they will be. At the other extreme, if we expect them to examine art, and to ask questions about it, they will do that.

Breakable art objects are only smashed in schools where the teachers expect them to be smashed. Where paintings of nudes are displayed by teachers who expect interest to be shown, the reproductions are not defiled, but discussed.

I asked them to look at the oil pastels . . .

The teacher chose the tools. That breaks some of the rules of our book: why didn't the teacher let the children choose? After all, as we have argued in our introduction, choice is a profoundly educational activity. We asked the teacher, and she answered:

> Because oil pastels are messy, and don't look nice except when they are new. And they tend not to choose them. Also, they look like crayons, and they mix them up with crayons. The mask is a very textured thing, and I thought the oil pastels might show that up. I showed the children how they can draw, or make, the texture by drawing with the side of the pastel, smudging it, rubbing the colours together, pressing on very hard, or very softly . . .

Though they didn't choose their graphic tools, the children then 'chose the colours'. But it would be confusing for the children to have to make every choice about every element of play and work.

> One of the children thought it was an egg, and he wanted to open it . . .

We note here how the teacher encourages hypotheses, and supports them even if she knows they are wrong. It is not for us teachers to get things right, but for the children to do so.

'Where is my drawing? . . . He is saying "I am here!" ' We should not underestimate the extent to which children, if allowed, claim possession of their work. Making a mark is making a statement about our existence, and to destroy or otherwise play down the marks a child makes is to make a cruel statement about that child's humanity.

But for some children, drawing consists of play (that escape into oneself). They don't need the end product: the activity itself was enough.

'He persevered'. The lesson here is, again, about expectations. A visitor to the school said about these drawings 'They're not by nursery children, surely?' This is wrong-headed in at least two ways. It suggests we have been cheating, drawing for the children; and it suggests that young children aren't really capable of surprising art. They are.

USING WORKS OF ART

While we were writing this book, we saw many children working with reproductions of works by Picasso. This is hardly surprising, because not only is Picasso a giant among twentieth-century artists in all media, visual, plastic, dramatic, literary, he is also quintessentially of his century. In his fractured canvases, he represents for us the 'heap of broken images' our century has become, and which the next century will inherit.

We recognise where we are and what we face when we look at *Woman weeping*, all acute angles (note how mathematical language haunts us!) and huge tears. And the huge painting *Guernica*, above all, stands up for our misery in the face of war.

These children have been looking at Picasso's work. Using a tool – felt tip pen – that Picasso had never heard of, one girl has produced an image of a human face, the blue part in profile, the green, half-hidden, full face (C39, page 139). All around this image is evidence

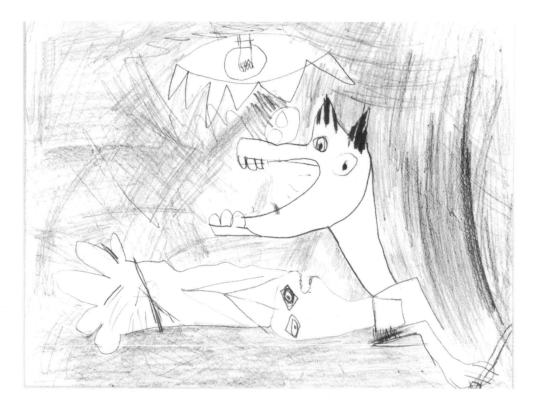

Figure 54 *Drawing after Guernica* by boy aged ten in felt tip pens

of a delight in colour and the graphic tool she has used, and reminders of some of the work of Matisse: the obsession with pattern, for example, in his interiors.

The girl who has painted the mother and child picture has been looking at work from Picasso's blue period (C40 on page 140). Note how we could have used this picture in the chapter on art and personal, social and moral education. Look how the child, though out of the mother's body, is also resting in the amniotic fluid, in the womb.

In another school, children have demonstrated that learning about modern painters is more than a matter of looking them up in books of reproductions and copying pictures in powder paint. William was eight when he made a drawing of a head in Picasso's *Guernica* (figure 54). The head he looked at is the screaming one leaning back in the top right hand corner of the picture. His first activity was to *choose* which part of *Guernica* he wanted to work on. His second was to observe, carefully.

Then he made a second outline drawing of a detail of his first (figure 55), and then a tracing of that (figure 56). His next task was to make a linocut of the head (figure 57), and then to make prints with it (figure 58).

Figure 55
Detail of Figure 54

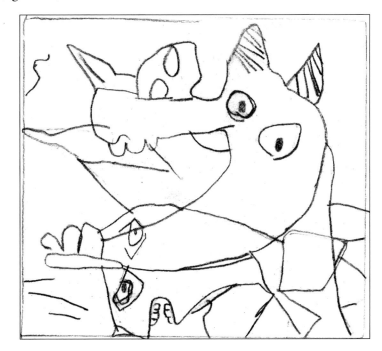

Figure 56
Tracing of Figure 55 by
boy aged ten in felt
tip pens

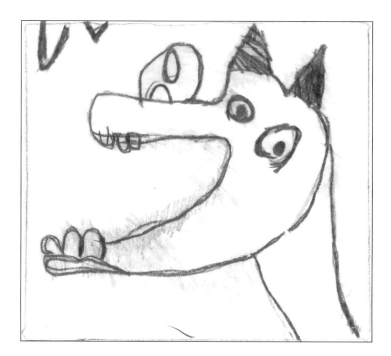

Figure 57
Linocut of Figure 56

Figure 58
Print of Figure 57

This lengthy, complicated process, which was broken up by other tasks in other subjects, and which probably took place over weeks, is fraught with learning, as the child makes choices, looks, draws, traces, cuts and prints. It represents a rich experience which he will probably never forget. In our science chapter, another child works from line drawing, through colour, to paint and material collage. As here, it is the process that counts, rather than the final product.

59 Linocuts based on Picasso by girl aged nine

Another child had a similar set of experiences with Picasso's *The Three Musicians* (not illustrated here). Two others have made mixed media print/paintings while looking at Picasso works (figure 59, and C43 on page 143). The boy who drew figure 60 has examined a Picasso picture in other media.

Art can never exist in total isolation from other learning. But we have written this chapter because all too often art becomes a mere servant to other subjects. This happens when children use art time to paint scenery, or when they slavishly copy Tudor paintings of royalty, and are not led to experience the language of art, and its elements, and are not able to experience its steady development throughout their school lives.

Figure 60 *After Picasso* by boy aged eleven, print/painting

Our argument is not that there is some proper balance to be found between art combined with other subjects on the one hand, and art for its own sake on the other. For us, it is a matter of understanding art in its most important role. It is about seeing art as a teacher. 'What lives in art?' asked the first child quoted in this book.

This is, by good luck, among other things, a very well-phrased question. There are many answers, of course: delight, to start with, and pleasure might do. Think of looking at your favourite picture or sculpture.

Then there is the thrill of recognising as general something we usually think of as particular to us: the innocent delight in Renoir's *First Date*, perhaps, or a particular element of a nightmare in a Dali painting.

There is also, sometimes, comfort: the Freda Downie painting reminds us of our friend Freda, of course, but also of young women we have made friends with, with similar expressive faces.

Art (to sum up these points) is a home for ways of helping us (as Samuel Johnson put it) 'enjoy and endure'.

But we here reiterate two points about that art's function as a teacher. First, the teaching happens, as far as the child is concerned, in an integrated way. Like the artist, the child does not separate her feelings from her thinking and doing. Neither does the child separate English from maths, art from science and technology, history from geography. It is the teacher and the monolithic system in which she works who demands that the child should split thinking from feeling or doing, and subjects from each other.

Second, the teaching that lives in art isn't just teaching for the child, it is also teaching for the teacher. As an artist pays total attention to her work, so she learns, so she makes art, and teaching is an art. As Simone Weil said:

> **. . . the development of the faculty of attention forms the real object and almost the sole interest of studies.**

Weil goes on to argue that if we are poor students at a particular subject, this is an advantage for developing our ability to attend. Every act of attention to something that we do not understand – 'this apparently barren effort' we will find one day 'has brought more light into the soul'.

These are huge claims for the power of attention in teaching and learning. It is our belief that art can make active, can make real, can *realise* those claims better than anything else education or schooling (and it is worth constantly reminding ourselves that those two are not necessarily the same) can offer us.

But art, we have said in different ways, can teach everything. It teaches by teaching the power of what Weil calls 'attention'. Margaret Morgan, in *Art 4–11* (1988), quotes a ten-year-old boy's poem

written with one of us fifteen years ago, under the influence of
Miroslav Holub's poem 'The Door' (see Summerfield 1970):

> Open the curtains please,
> get some light in this room.
> Get rid of the darkness and have some light.
>
> Let's look at the sun.
> Let's look at the roses.
> Let's look at the wet grass
> with a carpet of dew on it.
>
> Look, let's enjoy this moment. It won't,
> it won't happen again, I know it won't.
> Look, just through the glass in the window.
>
> See the sky, see the other houses,
> look at anything you can.
> Just look.

Art is all too often, as Shakespeare put it, tongue-tied by authority.
We might think of censorship, or the National Curriculum's lack of
space and energy spent on art, compared to the energy spent on
science and technology.

We read of education authorities selling off their collections of
original art. Art as a subject in our schools has been cut down because
it isn't practical. But art can teach science and technology, practical
subjects vaunted on pedestals built for them over the past fifteen
years.

Perhaps George Bernard Shaw was exaggerating when he said 'fine
art is the only teacher except torture'. But fine art, if not the only
teacher, is indisputably the most humane and beautiful one.

References

Clayton, Martin. *Leonardo da Vinci: The Anatomy of Man*, London, Little, Brown, 1992

Cotton, John. *The Poetry File*, Windsor, Nelson, 1989

Dixon, Peter. *Display in the Primary School*, Peter Dixon Books, 30 Cheriton Road, Winchester, Hants SO22 5AX

Grant, Bill and Paul Harris. *The Grizedale Experience*, Paul Harris, Edinburgh, for Cangate Press, 1991

Heaney, Seamus. *Death of a Naturalist*, London, Faber, 1966

Hamilton, George Heard. *Painting and Sculpture in Europe 1880–1940*, London, Pelican, 1972

Harlen, Wynne. *Science in the Primary School*, University College of Swansea, Swansea, 1993

Holub, Miroslav. *On the Contrary and other poems*, Newcastle, Bloodaxe, 1984

Jackson, Margaret. *Creative Display and Environment*, London, Hodder and Stoughton, 1993

Johnson, Paul. *A Book of One's Own*, London, Hodder and Stoughton, 1990

Lancaster, John. *Art in the Primary School*, London, Routledge, 1990

MacNeice, Louis. *Collected Poems*, London, Faber, 1966

Mathieson, Kevin. *Children's Art and the Computer*, London, Hodder and Stoughton, 1993

McKee, David. *Not Now Bernard*, London, Anderson, 1980

Modern Painters, London Spring 1994

Morgan, Margaret. *Art 4–11*, Oxford, Blackwell, 1988; Gloucester, Stanley Thornes, 1995

Newland, Mary and Rubens, Maurice. *Some Functions of Art in the Primary School*, London, ILEA, 1983

Paine, Sheila. (ed.) *Six Children Draw*, London, Academic Press, 1981

Panichas, George A. (ed.) *The Simone Weil Reader*, New York, David McKay, 1981

Popham, A E. *The Drawings of Leonardo da Vinci*, London, Pimlico, 1994

Read, Herbert. *Education through Art*, London, Faber, 1943

Roberts, Keith. *A Gallery of Masterpieces from Giotto to Picasso*, London, Phaidon, 1974

Roeves, Emily. 'The Management of the Arts in the Primary School', unpublished thesis

Rogers, Malcolm. *Master Drawings from the National Portrait Gallery*, London, NPG, 1993

Rowswell, Geoff. *Teaching Art in The Primary School*, London, Bell and Hyman, 1987

Ross, Malcolm (ed.). *The Aesthetic in Education*, Oxford, Pergamon, 1985

Sedgwick, Dawn and Fred. *Drawing to Learn*, London, Hodder and Stoughton, 1993

Sedgwick, Fred. *Collins Primary Poetry*, London, HarperCollins, 1994

Sedgwick, Fred. *The Expressive Arts*, London, David Fulton, 1993

Sedgwick, Fred. *Personal, Social and Moral Education*, London, David Fulton, 1994

Sendak, Maurice. *Where the Wild Things Are*, London, Puffin, 1970

Spencer, Herbert. *Education*, London, Watts, 1929

Stenhouse, Lawrence. *An Introduction to Curriculum Design and Development*, London, Heinemann, 1975

Styles, Morag *et al. The Prose and the Passion: Children and their Reading*, London, Cassell, 1994

Sujo, Glenn. *Drawing on these shores*, London, Harris Museum and Art Gallery, 1994

Summerfield, Geoffrey. *Junior Voices: the fourth book*, London, Penguin, 1970

Tanner, Robin. Address to Wiltshire teachers, advisers and ex-pupils, Wiltshire, unpublished 1984

Taylor, Rod, and Glennis Andrews. *The Arts in the Primary School*, Brighton, Falmer, 1993

Tickle, Les. *The Arts in Education: Some Research Studies*, London, Croom Helm, 1987

da Vinci, Leonardo. *Notebooks*, selected and edited by Irma A Richter, Oxford, OUP, 1980

White, John. *Education and the Good Life: Beyond the National Curriculum*, London, Kogan Page, 1990

Whiting, Roger. *Leonardo: A portrait of the Renaissance Man*, London, Barrie and Jenkins, 1992

Colour Section – Art across the curriculum

Figure C1
Story chair from Malawi

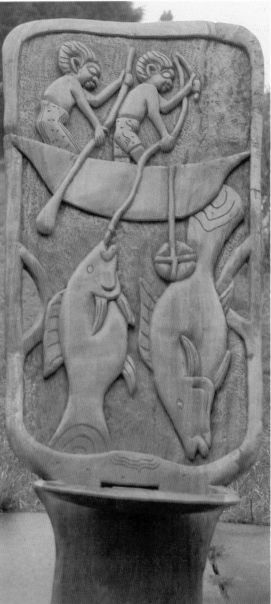

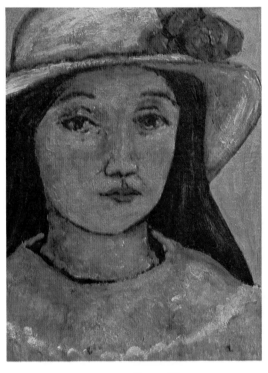

Figure C2
Freda Downie,
Girl with Straw Hat

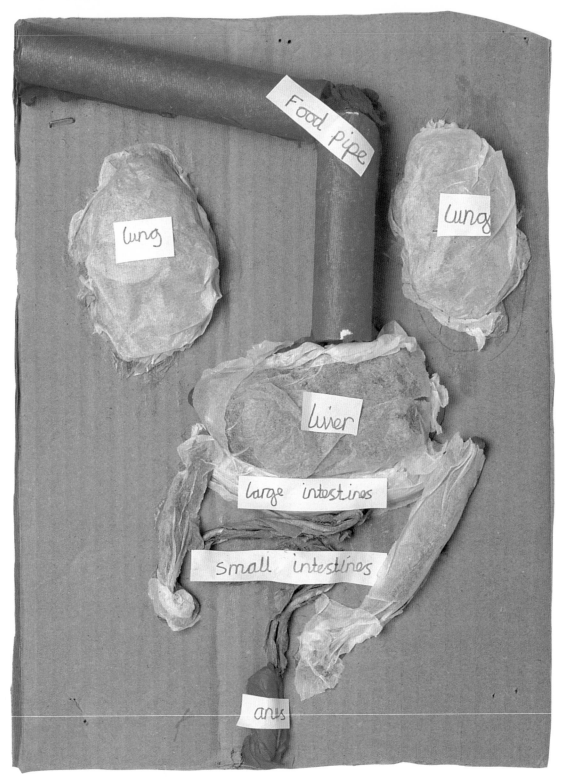

Figure C3 *Internal organs* by girl aged ten, mixed media

Figure C4 *Woods* by girl aged nine, photograph

Figure C5 *Woods* by girl aged nine, weaving

Figure C6
A little environment
by boy aged ten, paint

Figure C7
A little environment
by boy aged ten,
weaving

Figure C8
Shells by girl
aged ten, collage

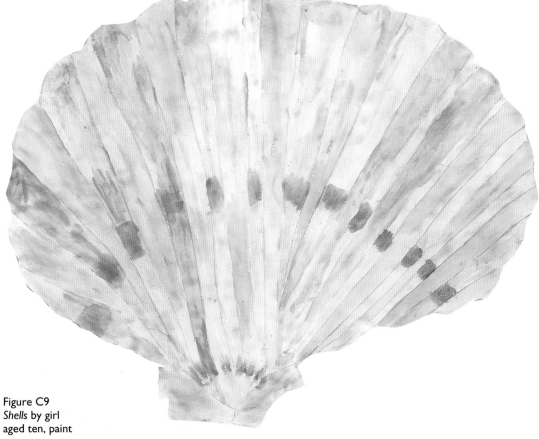

Figure C9
Shells by girl
aged ten, paint

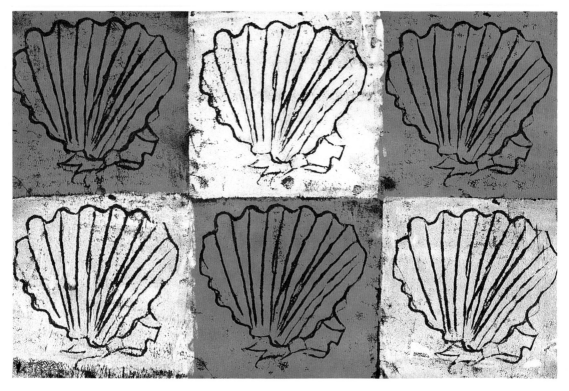

Figure C10 *Shells* by girl aged ten, print

Figure C11

Figure C12

Figure C13

Figures C11, C12 and C13
Building project

Figure C14
Squares
by girl aged five,
paper collage

Figure C15

Figures C15 and C16
Children working against a display background and triangles display

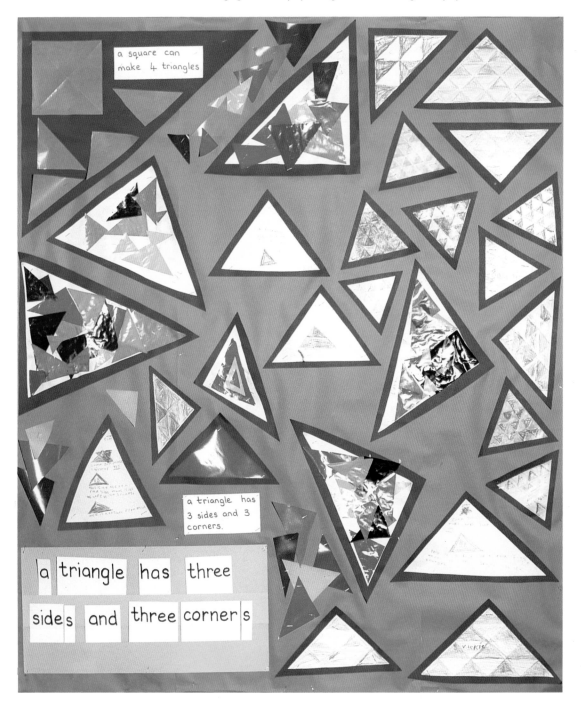

Figure C16

Figure C17 *Silver junk model* by a group of nursery children

Figure C18 Flower pattern by a girl aged nine, paint

Figures C19, C20, C21 and C22 *'To the artist mathematics is everywhere'*

Figure C20

Figure C21

Figure C22

Figures C23, C24, C25, C26, C27 and C28 Sequence from Big Bang to creatures coming onto land by a group of nine year olds, paint

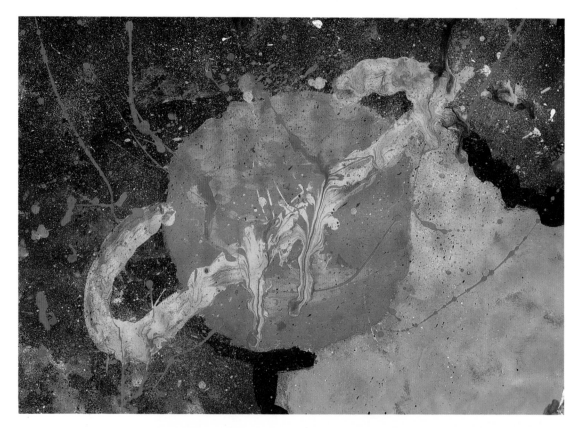

Figure C24

Figure C25

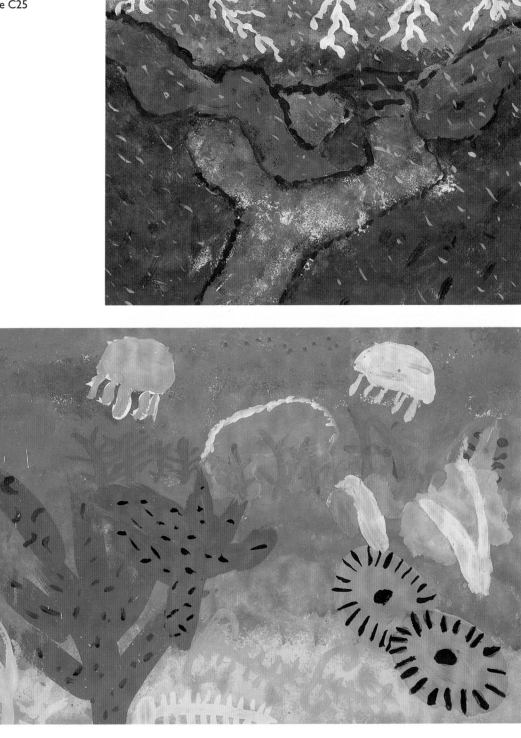

Figure C26

Figure C27

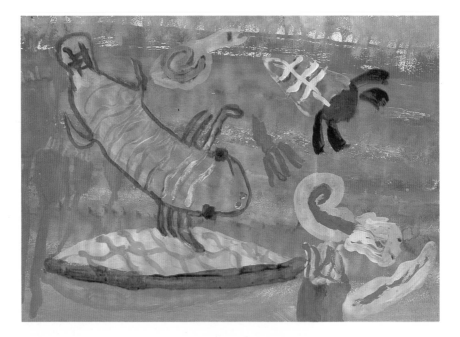

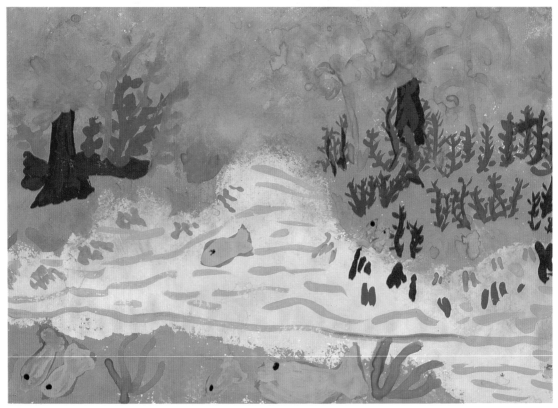

Figure C28

Figures C29, C30 and C31 Viking warriors and two Viking ships, by a group of children aged seven, in paint and collage

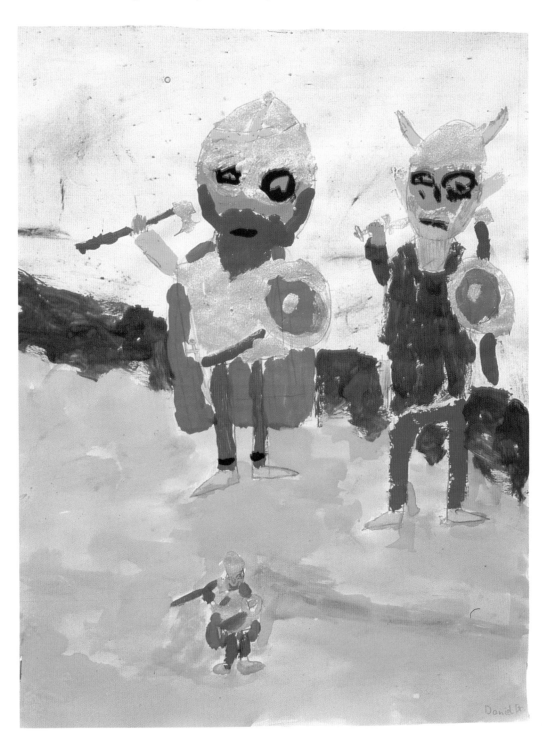

Figure C30

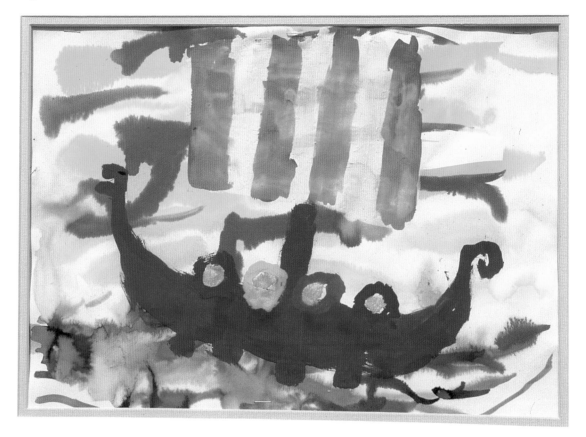

Figure C31

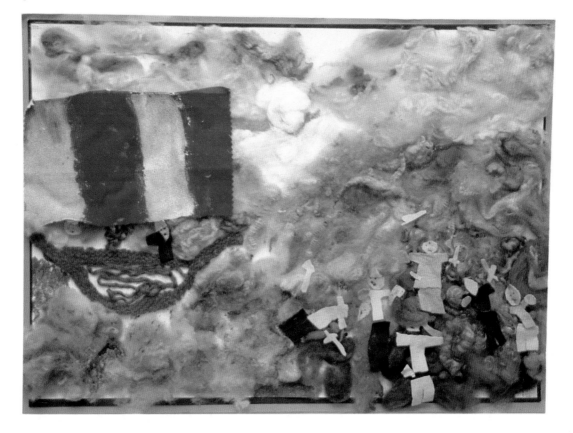

Figure C32 *Egyptian pattern* by boy aged eleven, print

Figure C33 *Sea display* by a group of eight year olds, mixed media slide

Figure C34 *Listening to The Blue Danube* by girl aged five, paint

Figure C35 *Listening to the African drums* by girl aged five, paint

Figure C36 African doll

Figure C37 *African doll* by girl aged four in crayon

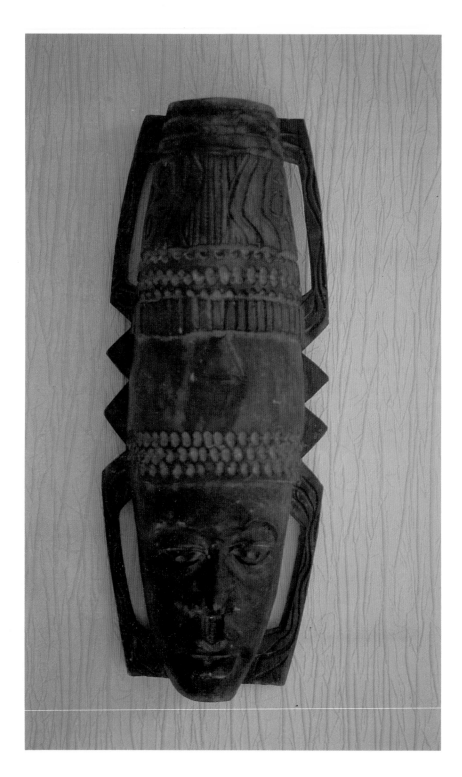

Figure C38 African carving

Figure C39 *After Picasso* by girl aged eleven in felt tip pens

Figure C40 *Mother and child* by girl aged eleven in paint

Figure C41 *Seedpod head* by boy aged four, crayon

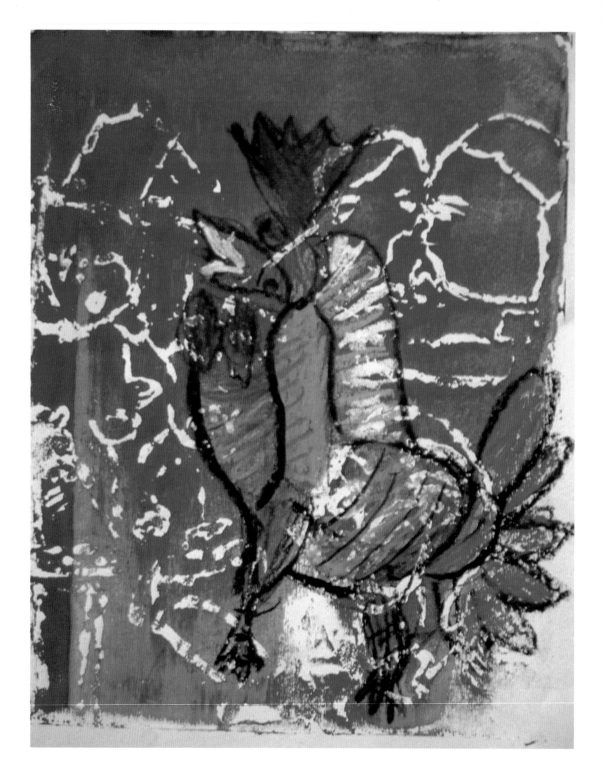

Figure C42 *Cockerel, after Picasso,* by girl aged ten, print/paint

Figure C43 *After Picasso* by boy aged eleven, print/paint